WILD CLAY

HERBERT PRESS
Bloomsbury Publishing Plc
50 Bedford Square, London, WC1B 3DP, UK
29 Earlsfort Terrace, Dublin 2, Ireland

BLOOMSBURY, HERBERT PRESS and the Herbert Press logo are trademarks of Bloomsbury Publishing Plc

First published in Great Britain in 2022

A catalog record for this book is available from the British Library

ISBN: HB 978-1-789940-92-3; ePub 978-1-789940-93-0

1 3 5 7 9 10 8 6 4 2

Designed and typeset by Plum5 Limited
Printed and bound in China by Toppan Leefung Printing

To find out more about our authors and books visit www.bloomsbury.com
and sign up for our newsletters

Front cover: Nine pieces of wild clay © Takuro Shibata
Spine: Press-mould bottle made with kaolin © Matt Levy
Back cover: Clay mine in North Carolina (top); Triangle jar, hand built, wood and salt fired (middle);
Test tiles fired in an electric kiln (bottom) © Takuro Shibata

WILD CLAY

CREATING CERAMICS AND GLAZES FROM NATURAL AND FOUND RESOURCES

MATT LEVY, TAKURO SHIBATA AND HITOMI SHIBATA

HERBERT PRESS

LONDON · OXFORD · NEW YORK · NEW DELHI · SYDNEY

CONTENTS

ACKNOWLEDGMENTS

To Randy Edmonson, Professor of Art Emeritus at Longwood University,
and John Neely, Professor of Ceramics at Utah State University,
for help and advice

To Ed Heneke, PhD, Bruce Gholson,
and Nancy Gottovi, PhD, for proofreading

To Mark Zellers and Kate Oggel,
for friendship and support

And to our sons, Ken and Tomo Shibata,
for making their parents happy every day

We thank you all

T & H Shibata

To my wife and partner in all things, Natalia
To Randy Johnston and Jan Mckeachie Johnston,
my mentors and clay parents

To Josh DeWeese and Dean Adams,
teachers, makers, and founders of International Wild Clay Research Project, MSU, Bozeman

To Tony Hartshorn and Margaret Boozer,
who showed me the world of clay beyond ceramics

M Levy

WILD CLAY

Chuck Hindes, woodfire artist and retired professor from the University of Iowa, always said, "I teach the world's most fascinating hobby," quoting the Duncan Ceramic Products slogan. Whether it is a hobby or a profession, ceramic art is found around the globe and across time. One might think this is because ceramic objects are fairly resistant to loss from environmental degradation, but an investigation of Professor Mark J. Winter's diffusion cartograms of the periodic table suggests another line of thinking. Professor Winter's cartograms are designed to teach undergraduate students relationships between elements. One particular cartogram tells our story. The entire periodic table is visible but only ten elements are discernable in the visualization. This cartogram shows Al, Si, and O as the largest cells and Fe, Ca, Mg, and Na as the next largest cells, followed by K, Ti and a very tiny H. It is titled "Diffusion cartogram representing element abundance in the earth's crust by weight." One of the reasons we find ceramics around the globe and across time is because our planet's crust *is* primarily the elements.

When we use the term "wild clay" we are speaking about clays that are not commercially available. All clay, after all, is indigenous to our planet. Commercial clays provide consistency and have been vetted by others.

Local clays offer unique colors and other qualities a specific artist might desire in their work. Wild clay also provides the satisfaction of sourcing materials oneself and, perhaps, utilizing materials near one's studio for aesthetic and environmental sustainability purposes.

In the great ceramic traditions of the world, we find unique subtle qualities in the materials reflecting the geology of the region. Before the modern age heavy materials were much more difficult to transport, so artisans found ways to work with the materials at hand, finding different means of expression in different parts of the world. Today, with modern conveniences, we are able to work with clays from around the world – truly a miracle. However, with that convenience we have eroded our collective sensitivity to one of the most significant dimensions of the ceramic arts; the prospecting, harvesting, and processing of our own indigenous ceramic materials. Clays have been invoked as the mold in which life evolved on Earth and they played a role in evidence of water on Mars. As the most ubiquitous material on our planet, it is no wonder that most of the record of human endeavor and culture is recorded in the ceramic arts found throughout the world.

Dean Adams & Josh DeWeese

WHY WILD CLAY?

Matt: Prospecting for local clay and materials isn't by any means a new thing. The ability to share information, and in particular the knowledge of how to process raw resources, has had a huge hand in the resurgence of digging and using local clays to either enhance or completely replace the use of commercial materials. The popularity of getting back to the source is fairly recent in the mainstream American ceramics scene and has been more of a niche thing in recent memory.

The history of ceramics is intertwined with that of civilization itself, so wild clay has roots in almost

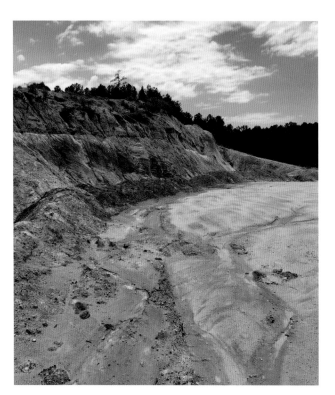

Photo courtesy of Takuro Shibata

every culture, with the detachments we have to the materials around us fairly new. Industrialization brought about material purity and homogony, and allowed potters to bypass the labor and risk of processing raw materials in favor of mixing pre-processed ingredients like feldspars, silicas, and grogs. Suddenly, making clay could be approached much like cooking from a prepared meal kit where you simply follow the given recipe and everything you need comes from a bag. While there's a trade-off in that the person saves time using commercially processed clays, they end up losing many of the unique qualities that exist in raw materials. There is also a level of learning and awareness that comes with sourcing and processing your own clays that makes wild clay a great educational tool. Students who are willing to move past the idea that clay comes from a bag and who immerse themselves in the world of processing found materials gain insight into the individual character of a clay and begin to understand what it takes to make a strong, plastic clay body.

Hitomi: In this super-convenient internet world, we can order almost everything online and it doesn't matter where we live and where we work. Clay comes in a cardboard box or a plastic bag. Clay companies have their own recipes for their clay products. If we are concerned about what materials are in these clays, how can we figure out what they are and where they are from? We have to choose which materials will make our clay work. Using wild clay locally for our pottery is like growing heirloom vegetables in the garden for our table. There is a lot of waiting time. We need to examine and

test, and we won't get immediate results. There might be many mistakes and false starts. If we want to make more money in our pottery business, then why would we use inconvenient wild clay? It could be a waste of time or effort so it might not be an ideal option for the business. I think it's the same as how we select what we eat every day, and how we pursue happiness in our life. We know there are many necessary steps to get the answers we are looking for and also there is a choice in our hands. As a pottery maker, I simply want to make beautiful clay works from materials that I know the origins of. Those materials are important parts of the body of my clay work. I love pots that have lots of unique and interesting stories about the potters, the materials, and the processes. That's the big difference between the industry-processed, mass-produced, machine-made ceramic products and the hand-made, wild clay pots.

Photo courtesy of Takuro Shibata

Takuro: In this book I would like to share information about my personal experience with clays and why I became interested in wild clays, as well as my process for finding, testing, and using them to make pottery and sculpture. My choice to use wild clays is not to seek out the perfect clay, but to learn about their unique characteristics and use them to create a clay body that showcases these properties. Because wild clays are not perfect in the commercial sense; they may contain impurities that, when fired, exhibit unexpected but beautiful results. Contemporary potters often look at ancient pottery as a reference for their own creative work. Today, we have an immense amount of information available to us through technology and we use power equipment to make laborious tasks easier. Does that mean we make better pots than those potters throughout history? Sometimes one may feel that the older pots seem more special, perhaps because the potters of old adapted their materials with little processing, accepting the resulting irregularities as a natural part of the making and firing cycle. All clays

come from the surface of the earth. They are the result of the gradual breaking down of rock into tiny particles containing alumina, silica, and water, as well as impurities such as organic matter, iron, calcium, etc. From its natural state, wild clay can either be used as it is or mined and processed commercially, producing a consistent, homogenous, and predictable result. I prefer to focus on the natural clays as they exist in the ground, with little or no processing. A clay found in its natural state is rarely perfect for making pottery, but it may be combined with another clay to make a good clay body for pottery production. As you dig, screen, blunge, and then test the clay, you will notice its unique properties and characteristics. Clays that cannot be used for forming pottery may be perfect when used as a slip or glaze ingredient. It is up to the individual to determine their uses. Some readers of this book may have different philosophies or perspectives about clay, so my ideas and my story may not apply to all. But I hope this book inspires you, in some way, to get your hands deep into your own wild clay.

A PERSONAL JOURNEY THROUGH WILD CLAY

It would be impossible to outline here the entire history of sourcing and processing raw clay. It has its roots in almost every culture across the globe, and since each deposit of clay is as unique, chemically, as the rock that surrounds it, we can only speak of the materials that we have encountered in our own personal experiences – from my time in Minnesota and Montana, sourcing local kaolin that was altered by glacial and geothermal forces of the past, to Hitomi and Takuro's time in Japan and then in North Carolina in the Shale Belts of the American South. Through these experiences, we shaped our understanding of local geology and the unique qualities of the corresponding clays, letting the materials inform our artistic practices as well as the processes necessary to make workable clay bodies from what was at hand. While our personal journeys are found elsewhere in this book, our hope is to share our direct experiences with specific landscapes. Whether you are prospecting for clays in your own backyard or searching the surrounding areas for specific materials, we hope that this book provides insight and helps in making the most of the materials you have at hand. From formulating clay bodies to making slips and glazes, or even pastels and paints, there are great opportunities to be found in sourcing local materials.

We, as the authors, only ask that you respect the landscape and communities around you. The opportunity to connect with people and source materials by understanding how past peoples utilized the land around them is crucial to finding viable resources in close proximity to where you live and to make art. In this first chapter, we share our experiences with specific areas of the world and how the clays found there inform the way we look for local materials now. These places have a rich history with clay, both in terms of culture and economics, showing how the prevalence and accessibility of workable clays in a given area can have a huge impact on community-building and the emergence of generational crafts and art-making. These examples are by no means isolated instances, and throughout the world there are fantastic and beautiful examples of cultures and communities connected to the landscapes around them through their contact with local clays. We hope that our words and teachings inspire you and push everyone to explore the rich history of ceramics through the lens of sourcing raw, local clays.

Nine different pieces of wild clay. Photo courtesy of Takuro Shibata

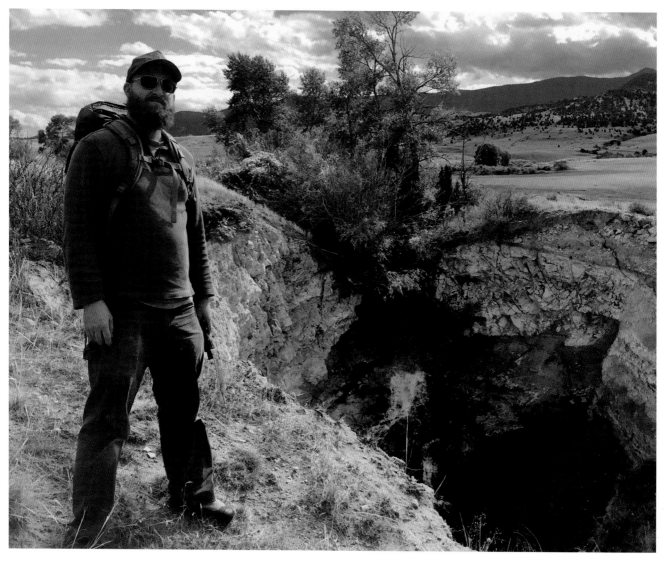

The author prospecting for kaolin deposits near Cardwell, Montana. Photo courtesy of Matt Levy

MATT LEVY

From Minnesota to North Carolina

Over the years, my relationship with clay has evolved, changing to suit my needs, time constraints, and interests. Where once I was a driven production potter, hovering over a wheel head and hard at work, I now hand-build forms, constructing pieces in a single sitting.

The ceramics I make are inspired by the textures I see every day while doing remodeling projects at work or at home. I see patterns in packaging goods and rich textures in construction materials. I try to take away from work any inspiration I can, often walking

out the door at the end of the day with scraps of plastic webbing or textured paper. I then distort these patterns, making them my own. My ability to construct has allowed me to fabricate all the tools necessary to have a fully functioning studio. I make my kilns as well as clay and glaze-making equipment.

Sustainability in Art has become my primary focus in recent years; most of the glaze chemicals I use have come straight from my backyard. Rather than focusing on ingredients mined in different parts of the country and the world, I have sought to be not limited but inspired by my surrounding environment. I recycle clay from local potters and add kaolin I harvest from the Minnesota River Valley area to create a smooth body suited for wood/salt firings.

Hand-built basket made with a local Minnesota kaolin flashing slip with beautiful fly ash deposits from a four-day anagama wood firing in Wisconsin, 2015. Photo courtesy of Nell Ytsma

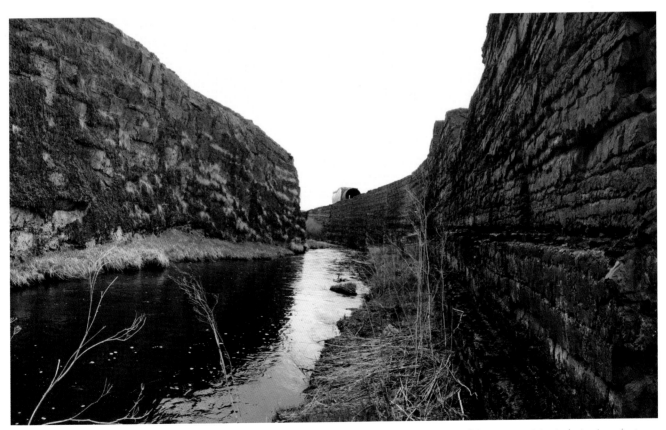

Slag walls surrounding Silver Bow Creek in Butte, Montana. These man-made walls are the remnants of the copper mining industry. In order to obtain precious metals such as copper and silver, the local bedrock was excavated, crushed, then superheated using lime, in order to melt the rock. Once the copper and silver were screened off the molten rock, the remaining leftover materials were poured in place forming the slag walls surrounding the creek. Rich in silica, calcium, iron, and manganese, the slag "rock" was an ideal material for experimenting with glazes like the bottle shown on p. 14. Photo courtesy of Matt Levy

Having grown up in Flagstaff, Arizona, I have a profound love for geology and the vast range of color, texture, and shapes found in rocks. My background, matched with my passion for ceramics, has been the catalyst for experimenting with natural materials using crushed stone, local kaolin/earthenware clays, and wood ash.

Press mold bottle made with kaolin dug in Montana near Helena. Glazed with crushed slag from Silver Bow Creek in Butte and wood fired for four days in a train kiln. The reduction-cooled effects bring out the iron and manganese found in the slag rock. Photo courtesy of Matt Levy

I have begun developing glazes and slips that complement my love for textures and atmospheric firings. As Japanese potter Shōji Hamada once said of his glazes, "My recipes may be simple, but my materials are very complicated." Minnesota has rich deposits of both clays and feldspathic rocks necessary for glaze-making.

While my beginnings in using local materials have their roots in sourcing clays out of the Midwest along the Mississippi and Minnesota river basins, my time in Montana defined my understanding of the relationships between clay and rock. During grad school at Montana State University, I worked alongside instructors and other grad students in fields such as Soil Ecology and Geology to find ways of talking about the landscapes of Montana through the materials at our feet. Not just rocks and clays, but even manufactured materials like slag from the copper mines in Butte and soils saturated with heavy metals, sourced out of Yellowstone National Park. These materials have viability as glaze materials and attest to the troubled past that Montana has with the environment and the cost of meeting the demands of the mining industry. My relationship with ceramics became more about the material narratives and less about making cups and bowls. Knowing our materials, where they come from, the cost of their processing, the inherent qualities they possess that can be both beneficial and detrimental; these factors all come into play when we start talking about material literacy.

My time in Montana researching local ceramic materials at Montana State University in Bozeman became a crucial step in understanding how the landscape comes to define the clay available in that specific area. With an extensive geological history impacted by geothermal forces, water, and freeze/thaw erosion, Montana has vast deposits of various clays spread throughout the state. These range from earthenware clays, rich in iron and manganese, to weathered rhyolite and

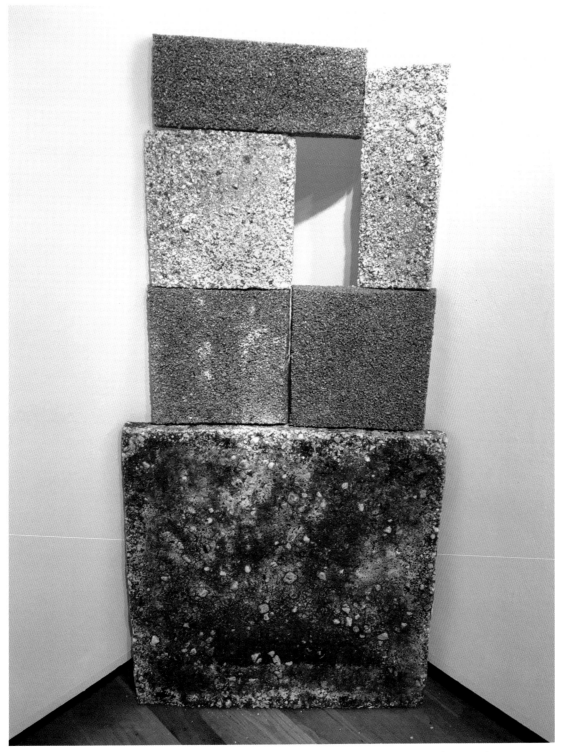

Work from my MFA thesis show. Fused rock tiles made from crushed granite, slag, and diorite rocks sourced in and around Butte, Montana. Fired to 2200 °F (1204 °C), allowing the material to fuse together to create solid blocks. Photo courtesy of Matt Levy

granite deposits, producing highly refractory kaolin clays. Montana's geology includes large sequences of Paleozoic, Mesozoic, and Cenozoic sedimentary rocks overlying basement rock formed in the Archean and Proterozoic ages. There are areas of the state with sequences of sedimentary rock up to 10,000 ft (3048 m) thick, while in other parts of Montana, primarily to the west of Missoula, these layers have been weathered away. With the abundance of sedimentary, igneous, and metamorphic rocks throughout the state paired with high levels of erosion, Montana was an excellent place to source materials for making clay bodies and even exploring rocks for use in making glazes.

After grad school, I was fortunate to have the opportunity to travel to Tasmania, Australia, and participate in a residency hosted by Ben and Peta Richardson of Ridgeline Pottery. I saw firsthand Ben's focus on sourcing local materials in Tasmania, not just because it was a personal choice but also out of necessity. In the US, we benefit from having access to many commercial materials, something not often found elsewhere. Seeing local artists like Ben and fellow potter Tim Holmes finding resources tied directly to the beautiful landscapes surrounding them and noticing how these relationships inform their practices has been truly inspirational. I left Tasmania and then traveled to New South Wales, where we stayed with Dr. Steve Harrison. Steve has been a massive influence for sourcing local materials and has written extensively on processing clay and

glaze materials from ingredients found within a short vicinity of his home in Balmoor, NSW. Just down the street from Steve was another great potter, Dr. Sandy Lockwood, who for many years has been mastering local materials to make dynamic sculptural forms that play with the atmospheric qualities of her wood-fired kiln. Both of these artists and educators recently battled wildfires, showing how precarious the changing climates are, and the danger of living within the landscapes that inspire and feed one's practice.

A custom wood kiln I built in 2017 at the Graduate Studios at Montana State University. I used the kiln to test clays and glazes prior to committing large quantities of work to bigger firings. It would fire for 16–18 hours to temperatures above 2350°F (1288°C). Photo courtesy of Matt Levy

Press mold plates glazed with a local Seagrove flashing slip and fired in a Japanese climbing kiln at STARworks Ceramics.
Photo courtesy of Matt Levy

After returning to the US, I was fortunate to find employment at STARworks Ceramics in Star, NC. There I worked alongside Takuro, helping to run both a clay business focused on sourcing and producing commercial clay bodies using local materials, and a residency space where artists can come and explore those local clays in their practices. Having secured a contract to write this book about wild clay, it seemed logical to join forces with Takuro and his wife Hitomi, and write this book together so we could combine our experiences in sourcing local materials.

Hitomi Shibata, portrait. Photo courtesy of Art Howard

HITOMI SHIBATA, JAPAN TO THE US

My Clay Journey

Asia has one of the longest histories of pottery-making in the world, and Japan, my birthplace, plays an important part in that tradition. The oldest functional pottery in Japan is hand-made earthenware created by the Jomon culture (10,500–300 BCE). Clay was dug and formed completely by hand into functional and ceremonial ware that was then pit-fired.

The famous "Six Ancient Kilns In Japan" are named and defined by Fujio Koyama (1900–75) who was a well-known potter and also a scholar of the history of Japanese ceramics. Although pottery has been made throughout Japan, Mr. Koyama defined those six kiln sites as important ceramic communities. The six ancient kilns are Seto, Echizen, Tokoname, Shigaraki, Tanba, and Bizen. The common feature of those old kiln sites is that they were built near clay mines and clay pits. Over the years and through generations, potters kept making pottery with local materials, experimenting, testing, and finding the best way to make beautiful pottery in their regional style. They were able to survive and thrive, as they continue to do to this day. This history has long been taught in university art programs, ceramic centers, and pottery schools throughout Japan.

I studied ceramic art in Okayama University's undergraduate and graduate programs from 1990–96. Bizen, one of the six ancient kiln sites, was very close to my university and I was able to visit Bizen pottery studios and participate in their wood firings as a part of my college studies.

After graduating from Okayama University in 1996, I decided to go to the Shigaraki Ceramic Cultural Park's Artist-in-Residence program. I was very excited to live in another of the ancient kiln sites, to discover what Shigaraki ware is and to experience local materials and traditions.

During the time I lived and worked in Shigaraki, from 1996–2001, most ceramic productions were tiles, planters, large-scale ceramics, and mass-produced tableware. There were several clay companies and a ceramic co-operative in town where local potters and members could buy a wide selection of clays made from local materials and also products from other ceramic industrial areas.

There were also many small-scale studios where potters made by hand tableware, tea wares, vases, and pottery for daily use. Some were contemporary and some were traditional. Their purpose was to make high-quality pottery by hand, and, although not a major part of the ceramic business in Shigaraki, it showcased traditional styles and traditions of the region. Those potters were very concerned with their materials, production, firing methods, and business strategies, because of their artistic and aesthetic goals and competitions. They worried about the long-range availability of their Shigaraki local clays because some were becoming hard to find or had disappeared completely.

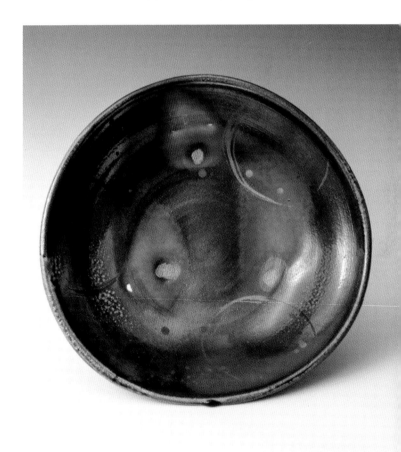

Hitomi Shibata: Wild Clay Platter, anagama fired, C11, 2017, local stoneware wild clay, iron oxide, 13 inches (33 cm) diameter x 1.6 inches (4 cm) high. Photo courtesy of Takuro Shibata

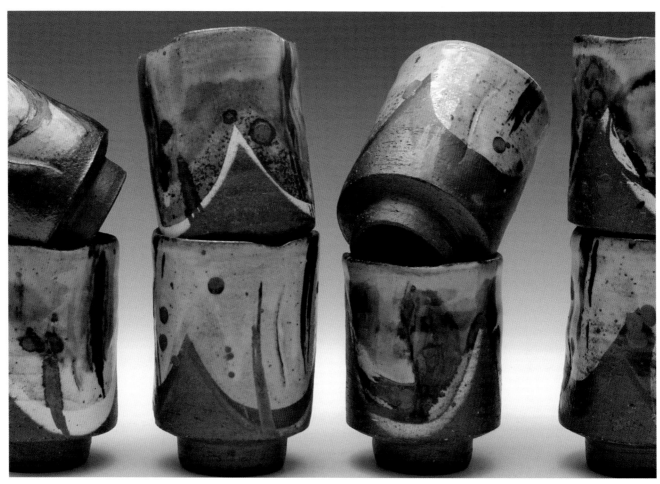

Hitomi Shibata: Yunomi teacups, wood fired, C11, 2020, local stoneware clay, iron oxide, 3 inches (7 cm) diameter x 5 inches (12 cm) high. Photo courtesy of Takuro Shibata

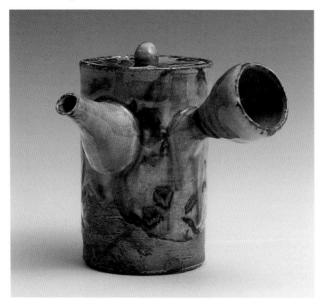

Hitomi Shibata: Japanese teapot, wood and salt fired, C11, 2019, local stoneware clay, iron oxide, 3 inches (8 cm) x 4 inches (10 cm) x 3.5 inches (9 cm) high. Photo courtesy of Takuro Shibata

Hitomi Shibata: six different NC wild clays. Photo courtesy of Hitomi Shibata

Hitomi Shibata: Wild Clay Platters, before firing, 13 inches (33 cm) diameter. Photo courtesy of Hitomi Shibata

Hitomi Shibata: Wild Clay Platters, after wood firing, 13 inches (33 cm) diameter. Photo courtesy of Hitomi Shibata

I was fortunate that I had the opportunity to work at the Shigaraki Ceramic Research Institute, which is funded by the Shiga prefectural government, as a research assistant on two occasions in 1998–99 and also in 2004–05. My job at the institute was making clay tests for the scientists at the institute. My supervisors gave me clay recipes and I made lots of clay test bars every day. These clays were like fine ceramics, super-light clay which could float on water, recycled clay made from fired porcelain products, and Shigaraki aplite with bacteria and bentonite. My hands got dry and scratchy sometimes, but I quickly learned about ceramic materials, clay lab equipment, and how to test clays and analyze the results.

I was not from a pottery family nor raised in a pottery town, but I had a decent education at my university, established a professional career in pottery villages, and learned a lot through my jobs as a young potter in the old pottery villages. I am also very fortunate to have traveled to many pottery communities, ceramic art centers, and potters' studios around the world. This has made me aware

of how potters make their ceramic works using local resources, and how the pottery communities were started and kept the businesses going throughout history. There are many unique clays in many countries, all with interesting stories, and I have a lifelong curiosity to discover and try to understand different materials in many locations in the future.

Hitomi and Takuro Shibata's wood-firing kiln at Seagrove, NC. Photo courtesy of Takuro Shibata

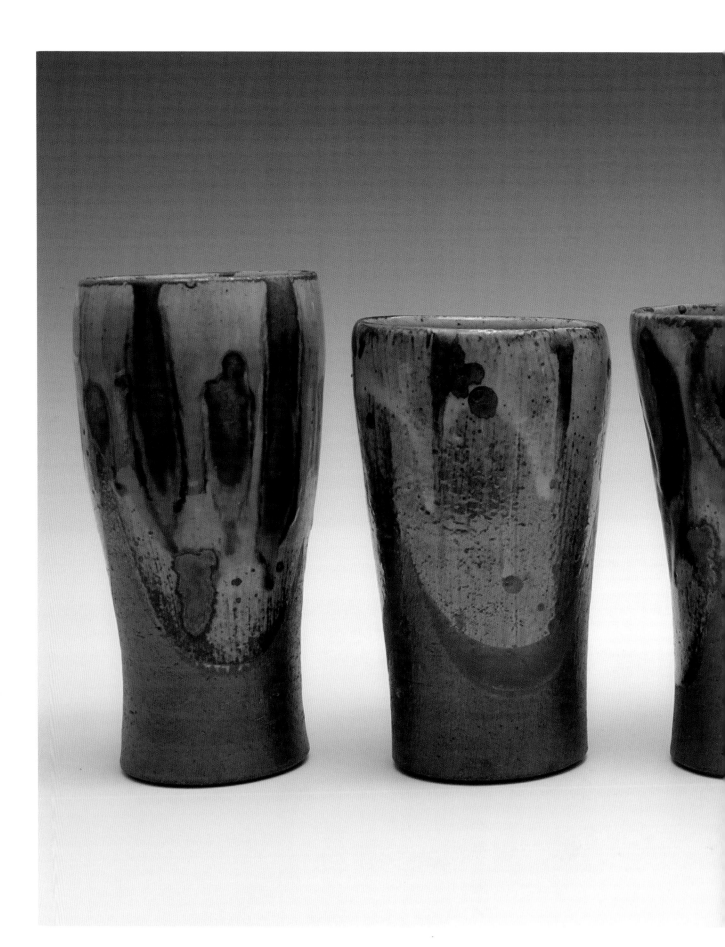

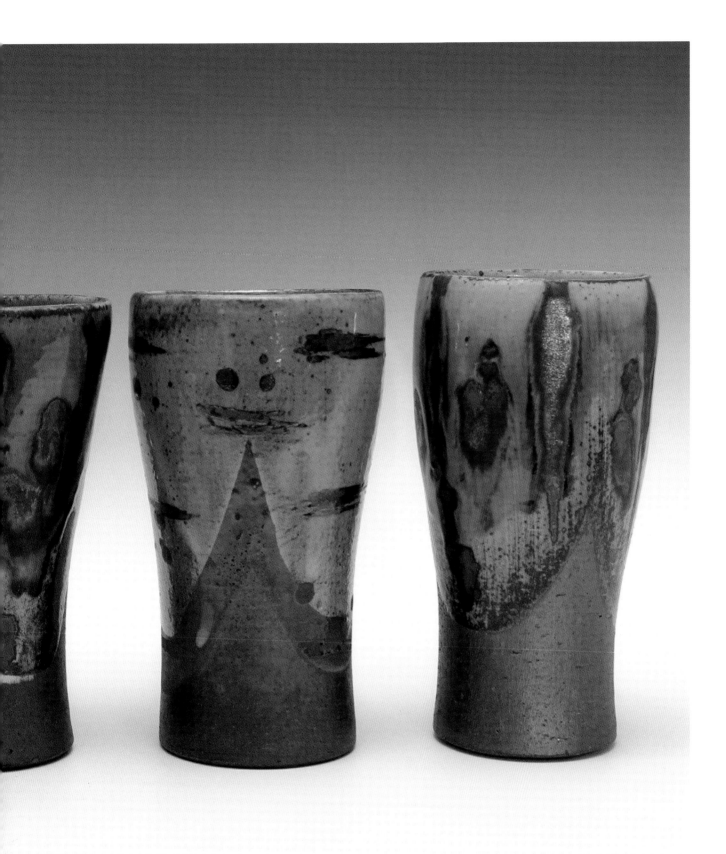

*Touya raw yellow clay after partial processing.
Photo courtesy of Hitomi Shibata*

*Previous page: Hitomi Shibata: Tumblers, wood fired, C11, 2021, local
stoneware clays, iron oxide, ash glaze, 3 inches (8 cm) diameter x
7 inches (18 cm) high. Photo courtesy of Takuro Shibata*

Experiencing wild clay in North Carolina

My husband, Takuro Shibata, and I moved to the US
in 2005, settling in Seagrove, NC, where we were
instrumental in establishing STARworks Ceramics
Materials and Research in Star, NC, and began
processing local wild clay for use by local potters.
This area has been known for its pottery production
for centuries. It is not always easy for newcomers
to be involved in business in rural areas. The key
was to get to know generous local potters and clay
specialists, and ask them to share their knowledge and
resources. Many were familiar with the use of wild
clay historically and some continued to use the local
clays in their pottery production. We were able to
map the location of clay deposits in the general area.

It's exciting when I receive a sandwich bag of an
unknown clay and wonder how or even if this
material can be used. Sometimes it's too "short" (it
lacks plasticity) to throw or even pinch, but it might
work for making slips, terra sigillata, or as a glaze
material. Many wild clays could be used for ceramic
materials and the possibilities are unlimited. My
experience at Shigaraki Ceramics Research Institute
helps me to test and find ways to use a material, and
I enjoy making tests and examining the results.

We have beautiful yellow clay on our property that
we use to create color and texture on our pots.
Although it is "short", we mix it in combination with
other, more plastic clays. We don't know how much
of this yellow clay we have on our property, but we
are thankful for the current supply. In Japan there is
a saying: "Treasure every encounter, for it will never
recur." In Japan that is how we think of wild clay.
All of us need to appreciate Mother Nature and
use her gifts wisely and efficiently. It is quality over
quantity as we meet the challenge of a potter's life.

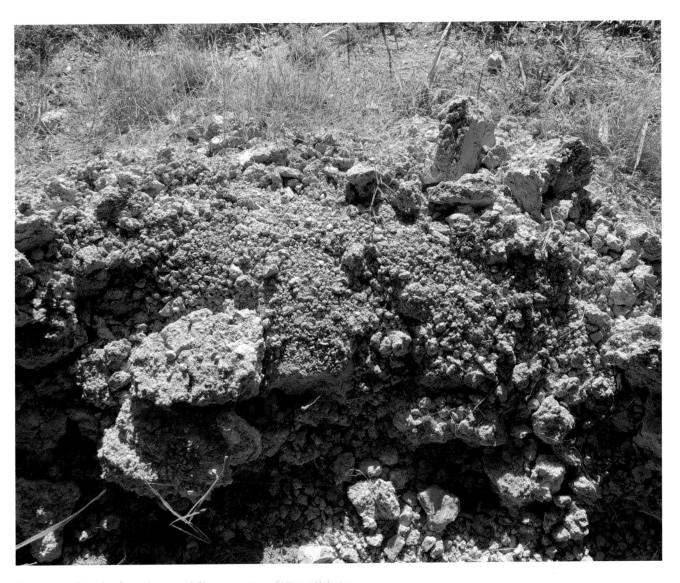

Touya raw yellow clay from the ground. Photo courtesy of Hitomi Shibata

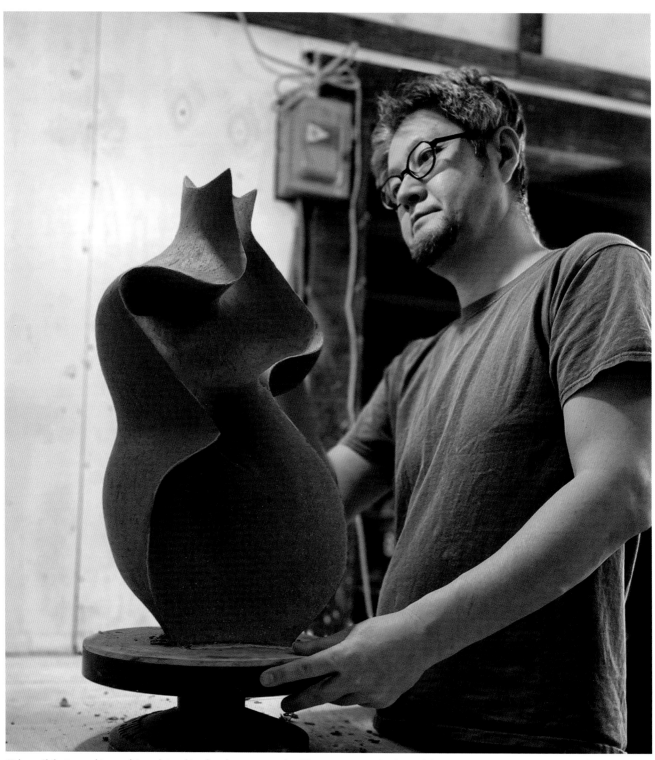

Takuro Shibata working on his sculptural jar, local stoneware clay. Photo courtesy of Takuro Shibata

TAKURO SHIBATA, SHIGARAKI, JAPAN TO STAR, NC

My Clay Journey

I earned a Bachelor of Engineering in Applied Chemistry from Doshisha University, Kyoto, Japan in 1996. My interest in ceramics then led me to take advantage of an opportunity to become an apprentice at the Tanikan Gama Pottery, one of Shigaraki's oldest pottery studios, in 1997. The first thing I learned as an apprentice was clay-making with local materials in Shigaraki. I wedged clay and cleaned the studio for the master potter, Hozan Tanii, who was also my supervisor at Tanikan Gama, from early morning to late night. My apprenticeship also afforded me a chance to interact with many other potters and ceramics businesses in the historic pottery town. I was very fortunate that I learned from local ceramic engineers and material specialists through my jobs every day for several years.

In 2001, my wife, Hitomi Shibata, received an opportunity to study at the University of Massachusetts Dartmouth under a Rotary Foundation Scholarship, and we came to the US for the first time. I had opportunities at art centers and pottery studios to learn how they make their clay bodies in New England. They had more scientific and engineering approaches to create their clay bodies that were very different from what I learned in Japan. The commercially mined, dry pulverized clays which are commonly used in industries are also used by potters and pottery programs. These commercial clays are made from industrial dry materials that are dumped into the clay mixer and have water added to create wet clay bodies. It is very efficient, quick, and controlled. I investigated where these powdered clays came from because I was very curious to see if there were any local clays nearby, but I did not have any success finding them while I was in Massachusetts, as an independent potter from Japan.

In 2002, Randy Edmonson, Professor of Art at Longwood University in Farmville, VA, invited us to teach a workshop at his school. While we were in Virginia, Randy took us to a new ceramic art center, the Cub Creek Foundation in Appomattox, VA.

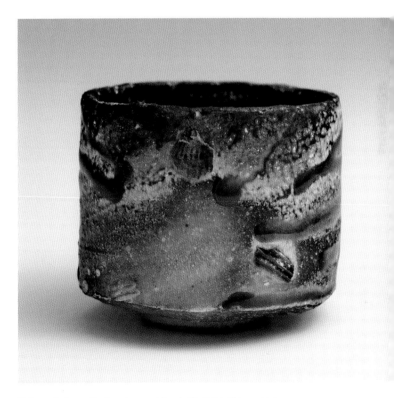

Takuro Shibata: Teabowl, wood fired, C11, 2004, Shigaraki stoneware clay, 3 inches (8.5 cm) x 4 inches (9.5 cm) x 3 inches (8 cm) high. Photo courtesy of Takuro Shibata

I had a winter residency program at Peters Valley School of Craft in New Jersey in November–December 2002. Bruce Dehnert, who is the head of the ceramic department, helped us fire Peters Valley's noborigama kiln, and we put many Cub Creek red wild clay test pieces in the kiln. We got interesting test results from the firing. The temperature was above Cone 12, approximately 2379°F (1304°C), but the red wild clay from Cub Creek survived the heat and it wasn't even vitrified. We were very excited about our first experience of working with wild clay in the US.

After Hitomi finished her program at UMass Dartmouth in 2003, we became artists-in-residence at the Cub Creek Foundation. As soon as we arrived there, we started digging more red wild clay, made lots of pots, and fired them in the Cub Creek wood kiln. We enjoyed processing raw clay and using it for our clay work.

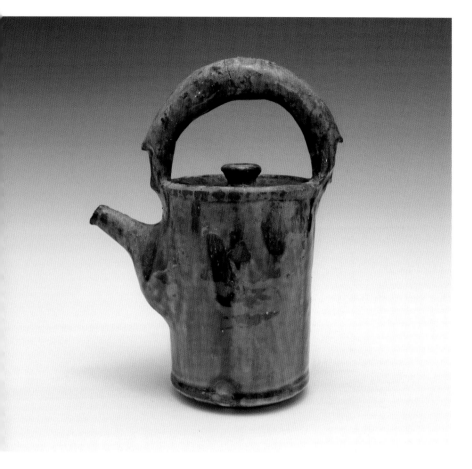

Takuro Shibata: Teapot, wood fired, C11, 2003, Cub Creek Clay mixed with Jessiman's stoneware clay, white clay slip, wood ash glazed, 7 inches (17.5 cm) x 4 inches (10 cm) x 9 inches (5 cm) high. Photo courtesy of Takuro Shibata

John Jessiman, who is the founder and executive director of Cub Creek Foundation, gave us a tour during our visit and showed us a brand new residency studio building. We noticed there was beautiful red clay behind the studio that the excavation of the studio building construction had revealed. Hitomi and I were so excited about the beautiful red wild clay that we took our shoes off and jumped into the clay puddles to collect samples in buckets. We took the clay samples back to Massachusetts and started making tests.

During the Cub Creek residency, we had a chance to visit our friends in Seagrove, NC – David Stuempfle, who is a potter, and Nancy Gottovi, Ph.D, who is an anthropologist. Nancy showed us around the area and introduced us to local potters. We were very excited that some potters were using local clays, but our time in the US was growing short. We finished our program at Cub Creek, then we left the US, traveled in Europe, and returned to Japan.

We loved our travels and were really attracted to the Seagrove area of North Carolina where potters used local clays in their pottery studios. Sometime after our return to Shigaraki, Nancy, the founder of STARworks NC, located just south of Seagrove, offered

Takuro Shibata: Platter, wood fired, C10, 2014, 100% single wild NC clay, 13 inches (33 cm) x 12 inches (30.5 cm) x 1.5 inches (34 cm) high. Photo courtesy of Takuro Shibata

Takuro Shibata: Platter, Slab, wood fired, C10, 2014, 100% single wild NC clay, 13 inches (33 cm) x 12 inches (30.5 cm) x 1.5 inches (4 cm) high. Photo courtesy of Takuro Shibata

Takuro Shibata: Platter, Slab, wood fired, C10, 2014, 100% single wild NC clay, 15 inches (38 cm) x 12.5 inches (32 cm) x 1.75 inches (4.5 cm) high. Photo courtesy of Takuro Shibata

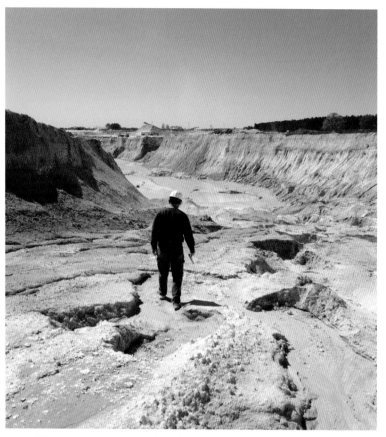

me an opportunity to establish STARworks Ceramics and to research local clays in the area. We made the life-changing decision to permanently close our studio in Shigaraki, sold all of our equipment and, with three suitcases and one cat, moved to Seagrove in 2005. I began work at STARworks Ceramics as director, and Hitomi started a two-year Artist-in-Residence program at the North Carolina Pottery Center in Seagrove.

When I started looking for wild clay in NC, a local potter friend introduced me to a ceramic engineer, Steve Blankenbeker, who works for a brick company in Salisbury, NC. I feel very fortunate to have met him, and to have learned so many things about wild clays.

Through wild clay, I met local people, made friends, and shared information, and it was an absolutely priceless experience.

One of the sand mines in NC. Looking for wild clays with Steve Blankenbeker. Photo courtesy of Takuro Shibata

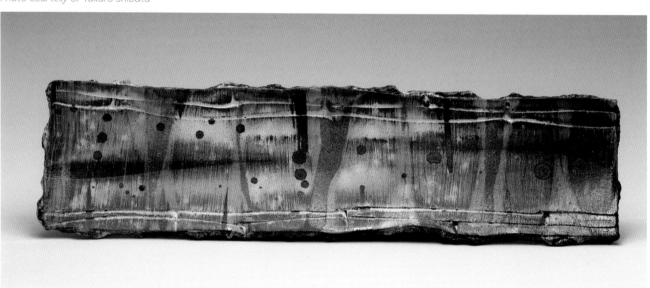

Takuro Shibata: Tray, Slab, wood and salt fired, C11, 2018, NC local clay, Kohiki, clear-glazed, Shino-glazed, iron oxide, 16.5 inches (42 cm) x 4.5 inches (11 cm) x 1 inch (2.5 cm) high. Photo courtesy of Takuro Shibata

I prefer to use local wild clay that is as minimally processed as possible because I would like to preserve its unique characteristics. If it's not plastic enough to throw on a pottery wheel, I use it for hand-building, slab-building or even clay slip. When the wild clay does not vitrify at a certain temperature, I fire it at a higher temperature. I believe that it is better to use the wild clay as it should be rather than the way I want personally.

I fire my work in our wood kilns that we built with the help of friends and many other people. Wood firing often creates an uneven reduction and oxidation atmosphere and temperature, but it also creates unexpected discoveries, and that inspires me to think of new ideas and to make new work.

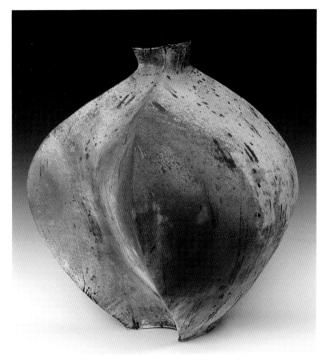

Takuro Shibata: Triangle Jar, hand-build, wood and salt fired, C11, 2016, local stoneware clay, iron oxide, 16 inches (40.5 cm) x 15 inches (38 cm) x 24 inches (61 cm) high. Photo courtesy of Takuro Shibata

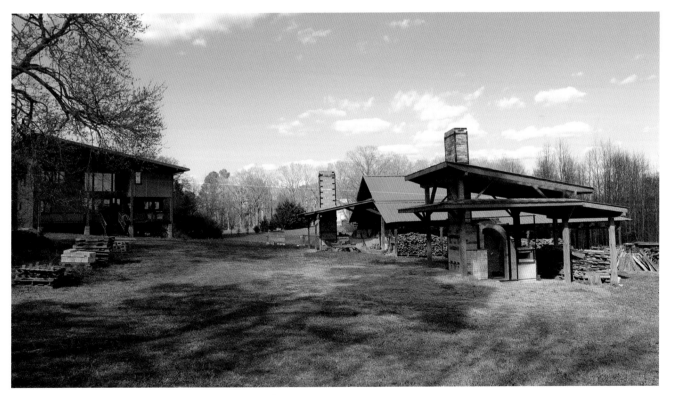

Studio Touya in Seagrove, NC. Photo courtesy of Takuro Shibata

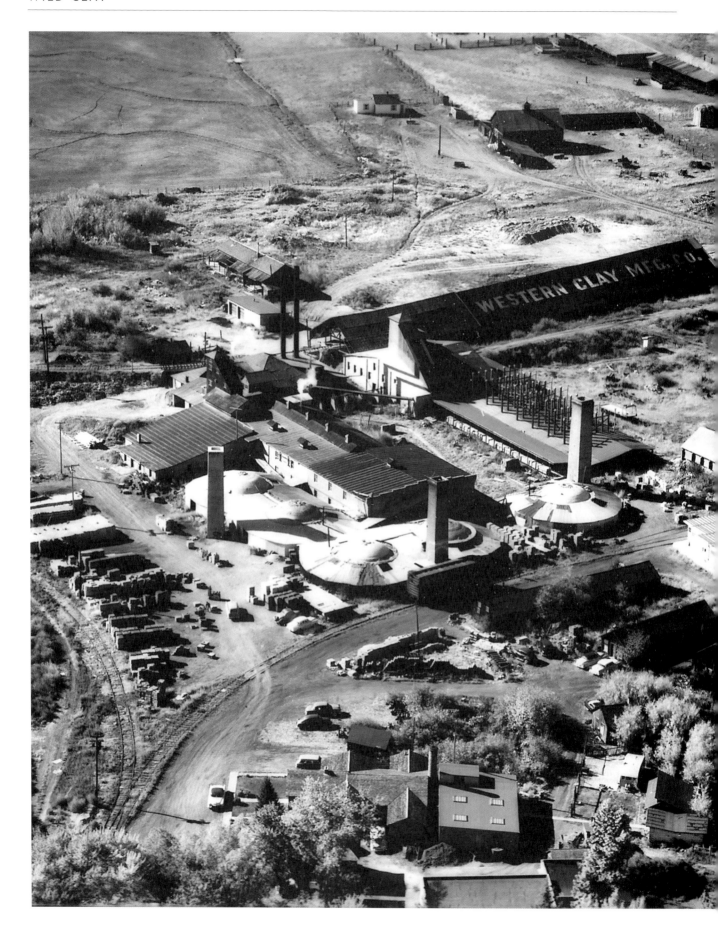

MONTANA AND THE ARCHIE BRAY

Montana is rich in opportunities for research and exploration, not only at an academic level through Montana State University and its programming that focuses on wild clay research, but also with the Archie Bray Foundation, located in Helena. Historically, local clays found throughout the western side of the state have been instrumental in Montana's history relating to mineral resources. The state is no stranger to brickworks, which is evident if you've ever been to the Archie Bray Foundation. The Foundation was originally the site of the Western Clay Manufacturing Company, founded in 1883 by Englishman C.C. Thurston and soon purchased by the brewer Nicholas Kessler in 1885. Kessler hired Charles Bray to manage the operation. Under Bray, the factory produced drain tiles, pavers, and other domestic wares such as flower pots. In 1905 Kessler joined forces with a local brickmaker, John Switzer, who owned a local clay pit near Blossburg, just 15 miles west of Helena, and Western Clay soon became the top brick producer in Montana. Charles's eldest son, Archie, took over in the 1930s, and the plant was operated successfully by him until his death in 1953, and then by his son, Archie Jr., until 1960. The ability to source local clays that were vitreous enough to be suitable for commercial production allowed the company to corner the market across the state.

According to the Montana National Park Service, "The Western Clay Manufacturing Co. produced some of the highest quality brick in Montana. Brick from this plant was specified by architects for some of the most prominent public buildings around the state and can be seen today in such buildings as Fort Harrison in Helena, the Federal Courthouses at Butte and Helena, the Civic Center and the First National Trust Co. in Helena, the state hospital at Galen, the campuses of the state university system at Missoula, Bozeman, Butte, Havre, and Dillon, and other buildings as far away as Kalispel and Billings (NPS)."

Aerial view of the Western Clay Manufacturing Co. taken at the height of the company's production in the 1930s–40s. Photo courtesy of the Archie Bray Foundation Archive

SEAGROVE AND THE POTTERY HIGHWAY

The unique geography and the abundance of easily accessible clays allowed for a saturation of potters in the Seagrove area not commonly found elsewhere. After potters – many of German or English descent – began to arrive in the area in the 1800s, the value of the silica-rich clays quickly became apparent. By the first half of the nineteenth century, many Seagrove potters began developing high-fired salt-glazed stoneware. At this time, the emerging railroad system came into play,

along with the creation of the old Plank Road. Originally planned to run from Fayetteville to Salisbury, NC, the Plank Road, together with the railway, opened up rural parts of North Carolina to trade and economic development. Seagrove artists quickly found larger markets for their wares, and many potteries adapted new styles to meet these demands. At the peak, over 100 different potteries were working in and around Seagrove proper, with many artists sourcing clays from around the area.

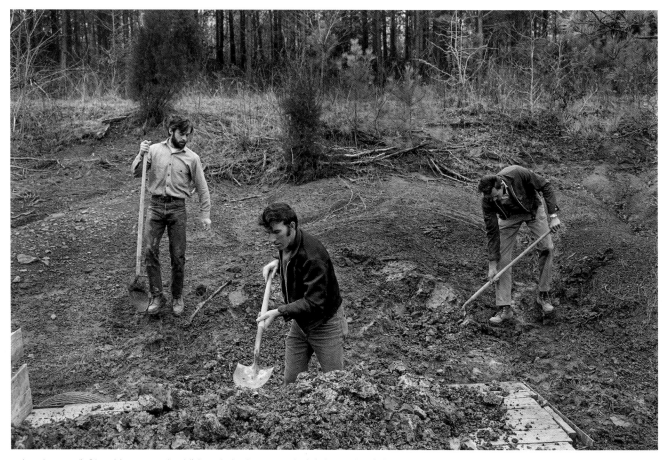

John Almquist (left), Bobby Owens (middle), and Charles Moore (right) digging local clay, circa 1972. Photo courtesy of Sam Sweezy

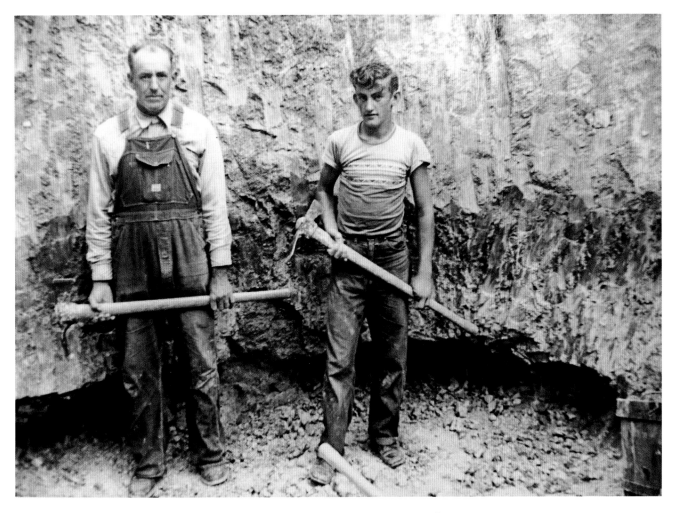

Boyce Yow and Pete Davis digging clay at the Michfield mine near Seagrove. Photo courtesy of Ben Owen III

With a renewed interest in the handmade object and a growing number of colleges and universities developing ceramic arts programs, the 1960s and 70s saw a demand for North Carolina pottery, and there was an increase of studio artists in the area. In 1982 a group of Seagrove potters started the Seagrove Pottery Festival and then the Celebration of Seagrove Potters, which convene on the same weekend in November. Highway 705 runs straight through the town of Seagrove and has become affectionately known as the "Pottery Highway."

Currently, there continues to be a thriving community of potters in and around Seagrove and other towns in the area like Candor, Robbins, and Star. Though many of these potteries now utilize commercial materials and clay bodies, many still carry on local traditions and source clay from an abundance of locations. Steve Blankenbeker, who sources clay commercially in the State, explains that "North Carolina is an excellent place to find clays because it is blessed with extremely diverse topography and geology.

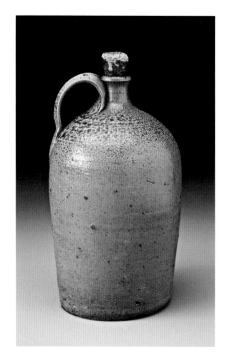

Salt fired jug by Rufus Owen, Ben Owen III's great-grandfather. Photo courtesy of Ben Owen III

Randy Johnston, Professor Emeritus at University Wisconsin-River Falls: Tea bowl, 100% Michfield clay, wood fired in noborigama at Mckeachie Johnston Studio, 2017, natural wood ash glaze, 5 inches (12.5 cm) x 5 inches (12 cm) x 3 inches (8 cm) high. Photo courtesy of Takuro Shibata

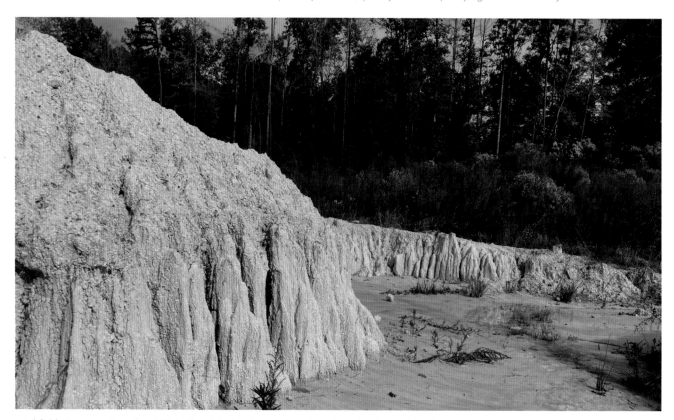

Michfield Mine, near Seagrove, NC. A silica-rich clay deposit thought to be volcanic in origin. Photo courtesy of Matt Levy

The slate goes from the ancient Appalachian Mountains in the west, to the foothills and Piedmont in the central part of the State, to the coastal plains out east. The vast assortment of clays available can be used to manufacture wares from low-fired red earthenware products to high-fired stoneware. Some of the whiter and purer clays can even be used to produce porcelain types and other whiteware products. There is probably no other state that can match North Carolina for the quality and types of its native clays."

Like many other places in the world where the abundance of raw clay creates cultural and economic centers for utilitarian makers, North Carolina has become a place where artists can connect with these materials and the surrounding landscape. Steve also points out that there are necessary factors that allow such a variety of clays to be easily accessible: "The geology includes massive deposits of weathered and unweathered granites and other hard rocks and minerals, the volcanic rocks of the great Slate Belt, extensive sedimentary floodplain deposits of several massive river systems that crisscross the state, and estuarine materials along the eastern shores. There are even bituminous coal deposits within the state. All of these contribute to make North Carolina an outstanding place to find a truly amazing assortment of different types of clay materials. Included in these clays are unique materials like primary kaolin and true fireclays. The river systems provide some outstanding secondary clays at many places. Within the volcanic slate belt there are interesting clay deposits of weathered rocks and ashes. The kaolin belt of the southeast crosses the state with massive deposits of high-grade white secondary kaolin clays."

Bizen clay

Bizen ware is the most unique pottery in Japan because the clay is dug from rice fields, the color is normally dark gray or black, and it is very plastic with rich iron in the clay. The firing range of this clay is lower than normal stoneware so that the wood firing's target temperature is lower but the length is much longer than any other ancient kiln sites in Japan.

Bizen potters do not decorate the pottery during forming very often, but they have special techniques of using rice straw, grog, saggers, and charcoal for loading and firing to get interesting colors and textures

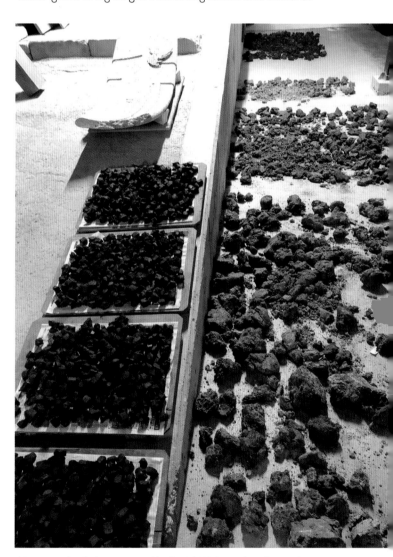

Bizen raw clay being processed by Ryuichi Kakurezaki at his studio in Japan. Photo courtesy of Takuro Shibata

in the wood kilns. The way local potters use their local wild clay was developed centuries ago, and Bizen pottery has not changed much to this day.

Bizen clay is the most at-risk clay in Japan due to the depletion of raw materials. The clay deposits lie under the paddy fields and the chances of clay digging are seasonal and occasional. Some potters try to use rough wild clays from mountains nearby but it's different from old Bizen clay. There are not many clay digging/supply businesses in the Bizen area and the shortage of clay has become a long-term problem.

Bizen is located in Okayama Prefecture, in a highly populated area between Kobe and Hiroshima, and rice fields are disappearing to give way to residential buildings. It's a tough situation for potters; not only are clay supplies affected but firewood is also an issue. In the tightly packed neighborhoods, the smoke from the kilns is also causing problems. Contemporary Bizen potters have begun to move from downtown Bizen (the area called "Imbe") to the suburbs to avoid the residential area.

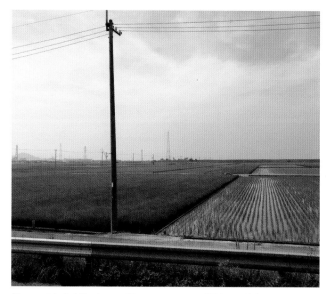

Rice paddy field in Japan. Photo courtesy of Takuro Shibata

Because of the unique traditions and ethics of using Bizen clay, we are seeing how the pottery community is facing a shortage of rare materials and how it is solving the problem. It could be the future of any potter's village in the world.

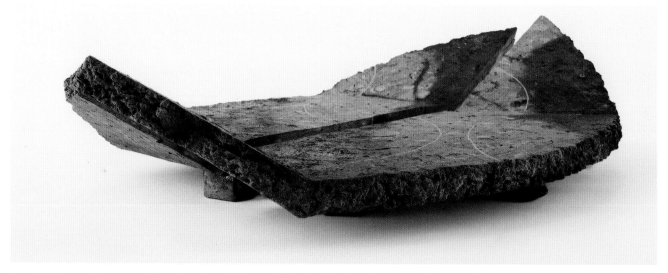

Ryuichi Kakurezaki: Hane-zara, "The wing platter," 40 inches (101 cm) x 12.5 inches (32 cm) x 5 inches (13 cm) high, Bizen clay, electric fired, 2013. Photo courtesy of Ryuichi Kakurezaki

Previous page: Takuro Shibata: Tray, Slab, wood fired, C11, 2004, Shigaraki stoneware clay, 5 inches (14.5 cm) x 17 inches (44 cm) x 1 inch (2.5 cm) high. Photo courtesy of Takuro Shibata

Old noborigama ruin in Shigaraki, Japan. Photo courtesy of Takuro Shibata

Shigaraki clay

Shigaraki is located east of Kyoto in Shiga prefecture, and south of Lake Biwa, which is the largest and oldest lake in Japan. Surrounded by high mountains, it is hidden from cities and major highways.

It is said that Shigaraki clay deposits were accumulated under the water of the original Biwa lake around four million years ago, before the lake moved to the north of Shigaraki. Later on, potters found plastic clays which used to be underwater. It is believed that Shigaraki's pottery production history began when tiles were created for Emperor Shōmu's Shigaraki-no-miya Palace in 742 ce, but the palace was never finished and was forgotten by the government. Other ruins in the area also help explain how Shigaraki pottery got its start.

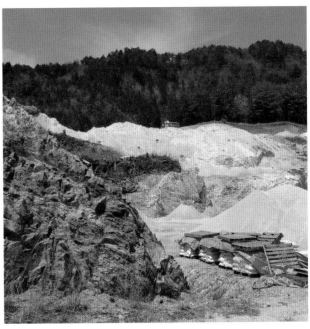

Feldspar mine in Shigaraki, Japan. Photo courtesy of Takuro Shibata

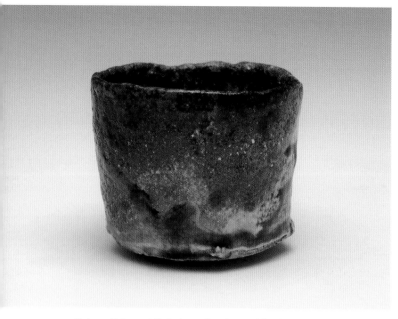

Takuro Shibata: Hikidashi Teabowl, wood fired, C11, 2004, Shigaraki stoneware clay, 4 inches (10 cm) x 4 inches (10 cm) x 3 inches (8.5 cm) high. Photo courtesy of Takuro Shibata

Serious pottery production in Shigaraki began around the end of the medieval period (*circa* thirteenth century), when potters created many different ceramic products, including large jars, containers, and other functional household items needed in cities and towns at that time.

Shigaraki clay is well known as very rough, coarse, rocky, and highly refractory. There are some large feldspar mines around Shigaraki which are a great resource for clay, glaze, and slip materials. As with the other historic kiln sites, Shigaraki was built near large deposits of usable clay.

Early Shigaraki unglazed pots range in color from dark brown to bright orange, but some had cracked and some were bloated. Their creators, potters who dug clay and fired it in Shigaraki-style anagama kilns, learned about their clays through many mistakes until they understood the characteristics and the limitations of their materials.

Now there are some commercial private clay companies and a clay guild in Shigaraki. They use some of the local wild clays to make a variety of clay bodies. Local potters normally buy wet clays from these clay makers, and blend them to make their favorite clay bodies.

In addition, there is the Shigaraki Ceramic Research Institute in Shigaraki, which is funded by Shiga Prefecture local government. The ceramic scientists research Shigaraki local clays to support the industry. Potters can visit any of these institutions and ask professionals to investigate technical and material problems. This clay research and supply system in Japan has been protecting and supporting the Japanese ceramic industry in many pottery villages for years.

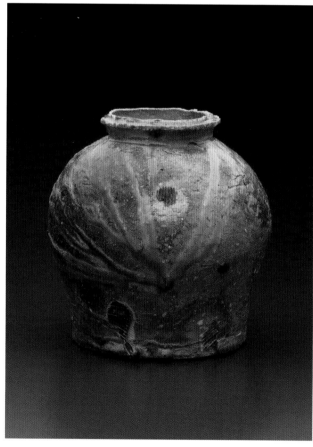

Kazuya Furutani: "Shigaraki Uzukumaru Jar", Shigaraki clay, unglazed, anagama fired, 9 inches (23 cm) x 13 inches (33 cm) high. Photo courtesy of Kazuya Furutani

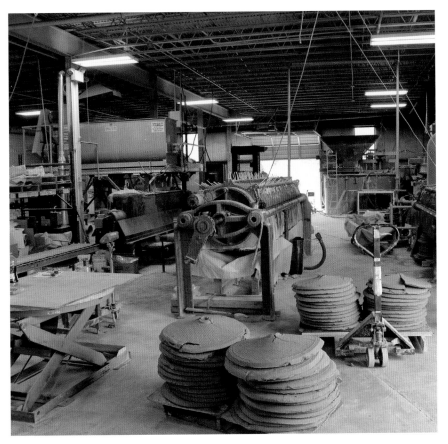

STARworks NC, clay factory, processing local NC wild clay, 2015. Photo courtesy of Central Park NC /STARworks NC

Iron-rich clay gathered in south-central North Carolina and used for making commercial clays at STARworks Ceramics. Photo courtesy of Matt Levy

STARworks Ceramics, Star, NC

STARworks Ceramics is part of a non-profit art organization which began in 2005 in Star, NC. STARworks began researching North Carolina clays and set up a small clay factory that has been producing local wild clay bodies since 2008. Its goal is to try to keep the unique characteristics of the wild clay as much as possible.

STARworks Ceramics provides clays to schools, arts organizations, and ceramic artists throughout the US. The clay factory has a 6000 lb (3 ton) blunger mixer to slake down the clays which then go through a vibrating screen to remove large rocks and impurities. The liquid clay is then transferred to a pressure tank that feeds into three filter presses. The clay cakes from the filter presses are then re-mixed and fed through de-airing pug mills and extruded into 25 lb (11 kg) lengths of clay. Though this filter process is quite common in other parts of the world to make clay, STARworks is one of the only clay companies left in North America that still uses this process, due to the labor intensiveness and costs in clay resourcing, researching, and production.

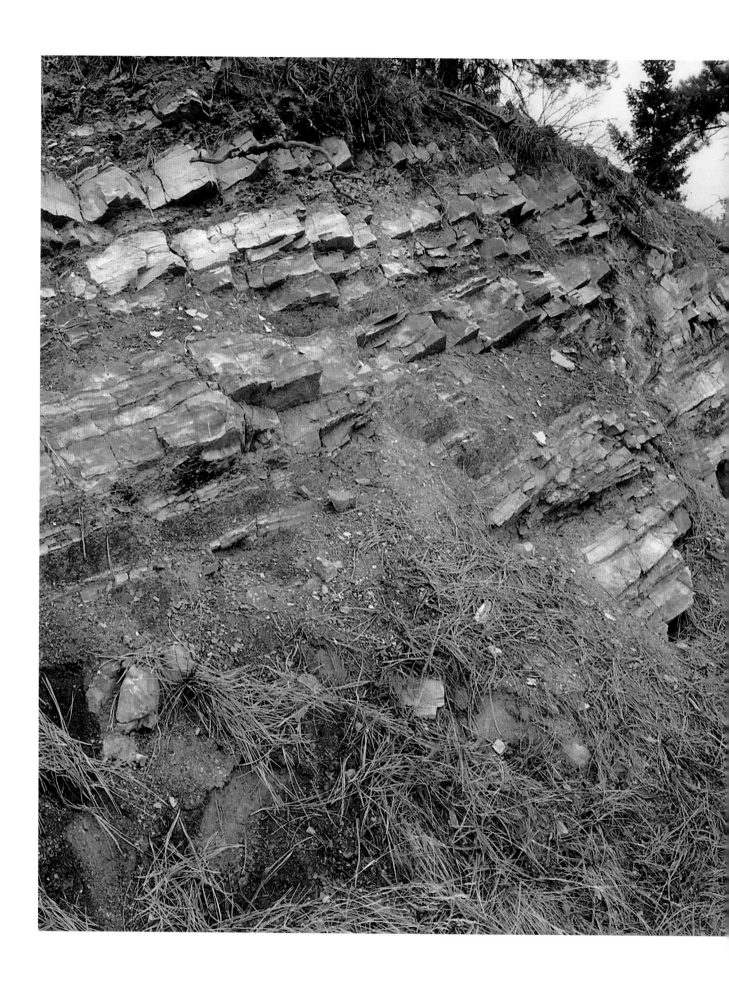

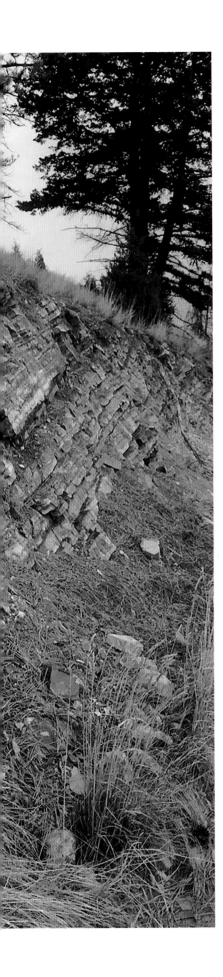

SOIL ECOLOGY AND GEOLOGY

The foundation of all clay formation is weathering, and since the presence of clay was crucial to the beginnings of life on Earth, we owe our existence to weathering and the soils and clays beneath our feet. The topmost layer of the Earth's surface, often referred to as topsoil, is only inches thick and primarily comprises many different minerals such as silica, feldspar, and rock particles. Aside from a small amount of organic matter, roughly 5% of almost everything else is open space, pockets of air, and other gasses present in the soil including methane, and, of course, water. This top layer plays a crucial role in the formation of clay and is very specific to the area of the planet where it occurs. Different patterns of weathering and erosion create different types of soil. They are characteristic of the parent rocks in that specific region, whether they be sedimentary rocks rich in calcium and silica or igneous rocks that contain high levels of iron and acidic minerals. Areas that experience higher weathering patterns, especially where more moisture is present, will often yield more extensive clay deposits. This is especially true for places where glaciers have receded or in tropical conditions with the constant presence of humidity and moisture. Soil texture is usually described in terms of the proportions of sand, silt, and clay, as shown in the table on p. 46, top left. At one end is quartz, or sand, with clay making the other corner. These hypothetically pure representations are rarely found on their own; instead, clays will always contain a certain level of sand and silt, along with organic matter. The amount of sand present in a found clay will be crucial to the clay's workability. Therefore, anyone prospecting for materials will be looking for clay lacking high proportions of sand and silt.

Roadcut near Phillipsburg, Montana, showing alternating layers of yellow and red mudstones from the Precambrian era. Photo courtesy of Matt Levy

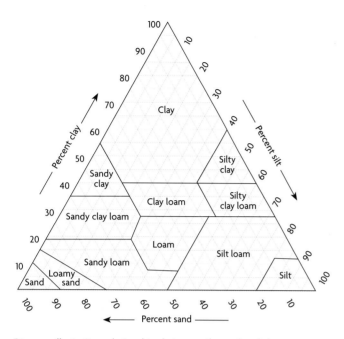

*Diagram illustrating relationships between silt, sand and clay.
Adapted from US Bureau of Soils.*

include higher levels of calcium carbonate and soluble salts. Clays found in arid landscapes are most often secondary deposits found in waterways and dry riverbeds. These clays are almost always secondary in nature.

Parent material a.k.a. "Who's your Daddy?"

Parent materials refer to the bedrock from which clay is made through weathering and erosional forces. Particular rocks must be present to form specific clays. Kaolins are necessary to make porcelain and come from low-iron rocks high in silica and feldspar, like granites. For any prospecting clay enthusiast, the phrase "Who's your Daddy?" is used to remind oneself that to find clay you must understand the underlying bedrocks of the area, especially if they aren't visible.

Clays develop due to the constant and intense weathering and erosional forces on the planet's surface, including the physical desiccation or breakdown of rocks and the chemical weathering of minerals. Clay development (kaolinization) is facilitated by multiple erosional forces, working independently or in unison, including moving water, wind, geothermal heat, and the downward percolation of water. Clays form via acidity most readily under temperate to tropical environments and where rain and precipitation are high. Acidic reactions in the soil, referred to as chemical weathering, allow for the formation of clay minerals and are most predominant in warmer climates. The abundance of plant life expedites the weathering process, breaking down rocks through acidification in the topsoils. Areas that are dryer and lack significant humidity levels have an opposite effect, and clays found in arid or desert regions tend to

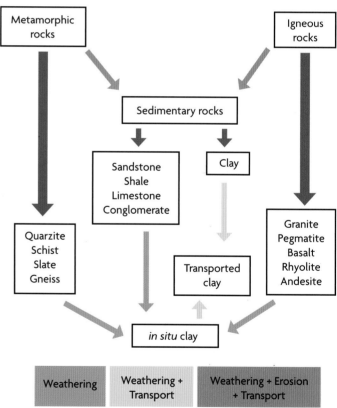

Weathering chart showing the traditional patterns by which rocks are transformed into clay. This process is cyclical, meaning that clays can return to being rocks and eventually weather into clay again.

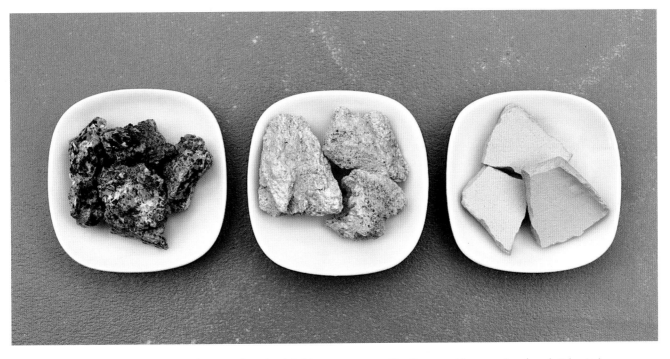

Minnesota pink granite in various stages from weathered rock (left), raw unprocessed kaolin sourced from an abandoned pit (center), to processed clay 60 mesh in size (right). Photo courtesy of Matt Levy

Clays are described as primary clays if they develop on bedrock directly or *in situ*, and secondary clays if they are generated through transported material via water and wind or glacial sediments. It is safe to say that any material subject to transport should be considered secondary, especially if it contains high amounts of impurities like iron and manganese. When referring to such clays, it is better to be specific and say "clays developed from unconsolidated material" because that distinguishes them from clay developed in bedrock through geothermal and acidic erosion.

Parent rocks, such as granite (see image above), sandstone, or rhyolites, will lead to the development of clays that are often high in free silica. Igneous material, such as shale or basalt, generates clays with little silica content, but clay is also rich in iron, manganese, and

calcium. The critical factor is the presence of feldspars which kaolinize during the weathering process.

Alluvial deposits are prized for good clay because they tend to be rich in ferromagnesian and other valuable minerals. Because kaolin clay particles have a negative electron charge and are larger in surface area, minerals like potassium, titanium, calcium, iron, and manganese – all with a positive charge – are naturally attracted to the kaolin particles, and thus become essential players for making clay bodies, slips, and glazes. With the inclusion of these additional minerals, one starts to see unique characteristics found in clays tied to specific areas; in other words, these "impurities" can lend character to the color, temperature range, and workability of the clays they are contained within.

*Micaceous clay casserole pit fired by Yolanda Rawlings.
Photo courtesy of Yolanda Rawlings*

Clay groups

Most clays associated with ceramics fall under
the kaolinite group, with a 1:1 ratio between
the tetrahedron silicon-oxygen layer and one
octahedron alumina layer that exists alternately
with a chemical structure of $Al_2O_3 \cdot 2SiO_2$.

Different types of commercial clay can be added to
your local clay to improve its workability and strength:

Kaolinite – China Clay. $Al_2O_3 \cdot 2SiO_2 \cdot 2H_2O$. The ideal
version of a true clay mineral. Most clays used by
ceramicists, besides Bentonite, contain kaolinite as a
primary constituent. The term "kaolinite" is reserved
for the pure form of the mineral. At the same time, the
word kaolin is used to describe the material that is clay
with minimal impurities like titanium, iron, etc. Kaolin
clay is usually found *in situ* as a primary deposit, often
near the parent rock from which it has weathered. If
the weathering is intense, like with geothermal forces,
large amounts of kaolin, intermixed with decaying
granites, rhyolites, and other igneous rocks high in
feldspar can be found. Kaolin is an excellent way to
add alumina to your clay and increase its peak firing
range. If you have a wild clay that is over-vitrified or
is starting to flux out at higher temperatures, adding
a kaolin clay can help to push the firing range.

Ball clays – Plastic, fine particle-sized clays containing
high amounts of kaolinite and other minerals like
potassium, sodium, calcium, and mica. Due to the
presence of this additional mineral, ball clays are often
less refractory than purer kaolinite clays. Most ball clays
consist of three minerals, kaolinite, mica, and silica.
They are sedimentary in nature, formed along ancient
river beds where water disperses the clay particles
into finer and finer particle sizes. There is a thick band
of ball clay deposits running through Kentucky and
Tennessee in the US, with some deposits found in
Canada around Southern Saskatchewan. Ball clays are a
primary constituent in many high fire clay bodies, often
paired with a particular type of kaolin. Ball clay is used
to add plasticity and green strength to coarser, less
plastic clays. They are also used for slip casting due to
their ability to stay in suspension and resist settling. It is
also essential to know that most ball clays have a high

shrink rate, as much as 20%, after being fired in a kiln, and need coarser materials to reduce cracking during drying.

Fireclays – These are sedimentary clays most commonly found below coal seams of the Carboniferous Period, where they were the base soil for the coal forests of that era. These underclays are usually found in a damp state, quickly breaking down into plastic clays with minimal processing. Rock fireclays and shales require more effort and must be crushed and milled to achieve a desirable level of workability. Alumina-rich, fireclays are generally considered to be a refractory material that adds green strength when included in plastic clay

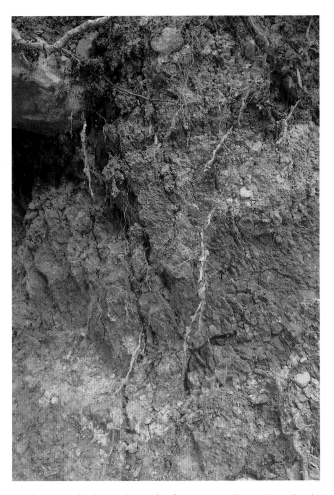

Earthenware clay located outside of Bozeman, MT, near Bear Creek. This material weathered from igneous and volcanic rocks into a mudstone and then encountered weathering again back into plastic clay deposits. Photo courtesy of Matt Levy

bodies. They often contain free silica and calcium carbonate in the form of lime. When using fireclays in clay bodies, it is best to screen the material in order to avoid introducing lime chips into the finished clay – the results of which are referred to as "lime pops" because the calcium carbonate particles rehydrate after firing and can chip off pieces of the surrounding ceramic as they expand. Fireclay is a primary constituent of high fire brick-making, and high alumina fireclays are used to make kiln brick and other furniture like kiln posts.

Lacustrine clay deposits – Also referred to as lake clay, these deposits are created usually over long periods of time with low-energy particle sizes and tend to be heavily laminated with various layers of silt, clays, and often carbonate minerals, as well as other impurities and metals that are reflective of the surrounding geology. Lake and basin clays are easily accessible in arid regions, but these resources are often rich in calcium carbonate and are therefore usually low-firing clays. Older deposits of lacustrine clays can be found in areas of higher elevation, where historic water levels have dropped leaving these clay deposits exposed on the banks of lakes and other bodies of water. Oxbow lakes can also produce lacustrine clays as rains and seasonal flooding bring in more sediment. Minnesota has a number of lacustrine clay deposits in and around Lake Superior that were largely formed by receding glaciers; these deposits dot many of the lakes found within the area between Minnesota and Wisconsin. As a rule of thumb, it is best to consider that many of these clay deposits found in and around lake beds contain high levels of sediment and fluxes, making them excellent glaze materials but not necessarily great for making clay bodies. As with anything on this Earth though, there are exceptions to any rule.

Micaceous clays – A term for a group of clays that naturally have high levels of mica, usually derived from sedimentary rock or mica/biotite-rich igneous parent

rocks. Usually, when someone refers to micaceous clay, they mean an earthenware-type clay found in arid climates and used to make traditional flame wares. Due to the presence of mica, these clays have resistance to thermal shock. Mica-rich clay also has alkaline properties, which can neutralize acids in foods like tomatoes and peppers, hence its historical use for making bean pots. Micaceous pottery used in cooking will heat more evenly, making these vessels ideal for slow-cooking meats and legumes. These clays tend to be less plastic and are usually used with traditional hand-building techniques such as coiling and burnishing. These techniques allow for the compression and packing of individual clay particles, increasing shear strength. Most pottery made in this fashion can withstand direct flame and years of use in the kitchen. Micaceous pots are still considered porous, like most earthenware, and one must burnish both the inside and outside if the pottery is intended to be used for cooking. There are other instances of more refractory clays, like kaolin and ball clays, containing high mica levels. However, these clays generally need other added materials to construct a workable clay body, whereas micaceous earthenware clays can frequently be used as a single source clay for making wares, often adding just a little sand or grog for issues regarding shrinkage.

Bentonite – The bane of any prospecting potter. These clays are derived from sodium- and potassium-rich volcanic ash and are generally found in thin beds throughout much of the US. While they seem plastic upon first inspection, and the potter may get excited over finding a white plastic clay, Bentonite also swells when hydrated, having a much larger shrink rate than other clay types, making it unusable in large amounts. Generally, one can add 2–5% bentonite to clay bodies for added plasticity, but anything over that amount and you'll begin to see issues with cracking and shrinking rates. Bentonite clays are great for glazes as they help with suspension without adversely affecting the dynamics of the melt.

It is best to be suspicious when encountering a thin vein of white/buff-colored material that initially shows plastic qualities. Due to the widespread occurrences of volcanic ash beds worldwide, Bentonite turns up frequently if you are out looking for viable sources of clay.

Earthenware – A generalized term for any impurity-rich clay high in iron, manganese, and calcium oxides. A secondary clay that has encountered transport through weathering, especially water, earthenware clays are typically very plastic and can often be considered a single-source clay body, requiring little in the way of additives in order to be used for making pottery. Earthenware clays can be derived from weathered igneous rocks like basalt or have originated as sedimentary rocks that are then weathered *in situ* or transported to another location. Each time this happens, the clays become finer in particle size and acquire more significant amounts of impurities, lowering their melting points. In this way, many low-fire clays can often become valuable as glazes and slips at higher temperatures. Most earthenware clays are red/orange in their unfired state – terracotta being a prime example. There are instances of white or buff-colored earthenware clay found wild, with calcium, soda, and potassium as the primary fluxes. More often, however, secondary clays come into contact with iron and manganese, creating earth tones in the clay's color. This is not always the case, and one should never assume that a white clay, especially one that shows signs of transport (found along river or creek beds or lakes), is a kaolin clay and will be refractory enough for use at high temperatures.

Marl clays – Clays that have been weathered from periods of glaciation can be tricky to identify due to the inclusion of other minerals, fossils, and organic/carbonic materials. Often in their formation into a rock, these clays are subjected to percolation of groundwater, which brings with it dissolved minerals

Clay derived from the Decorah Shale deposits found along the Mississippi River in Saint Paul, MN. This particular vein was exposed during the construction of a house foundation. Note the yellow specks of limonite present. Photo courtesy of Matt Levy

such as iron and calcium, salts, and even toxic minerals like arsenic and heavy metals. Marls have been historically used for earthenware and brickmaking.

Shale clays — Derived from sedimentary rocks, if found exposed to surface conditions and erosion, many shales can be easily broken back down into usable plastic clays. Even shales that are largely cemented together can be crushed and milled into suitable clay for pottery-making. There are extensive Decorah Shale deposits in Minnesota; some in areas where the rock is still resistant to erosion and largely intact, and others where the

shale has decomposed back into clay. Shales are often accessible via road cuts and old quarries, though be warned that due to most shales being relatively soft and vulnerable to erosional processes, abandoned quarries and hillsides are often unstable and can be dangerous to go digging in. That being said, shales can be an excellent source of plastic, fine particle-sized clays. The mineral makeup of shales varies greatly, with some containing high levels of calcium and soluble salts, while others may be purely fine-grained clay. There are usually impurities present, so extensive testing is required before committing the material to a specific firing temperature.

Ochres

Ochres are considered a specific group or family of earth pigments and are essentially variations of ferric oxides mixed with varying degrees of clay and sand or a calcium-rich, chalky consistency. Usually, the percentage of ferric materials is above 50–60% and is seen as impure iron ore, often found alongside other minerals though rarely itself in large deposits. Ochres are non-toxic and can be quickly introduced into slips and glazes where iron reds are desired. Three minerals predominantly make up the natural range of earth pigments: limonite, hematite, and goethite.

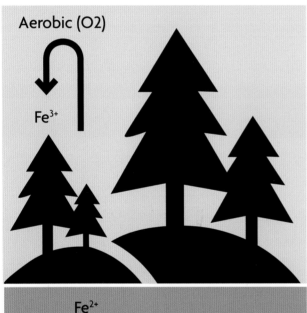

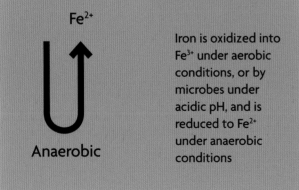

Diagram showing how iron oxidizes when it comes into contact with oxygen on the surface, and how a similar process takes place underground where iron oxide undergoes a chemical change when exposed to microbes and acidic conditions in the soil.

Limonite – Yellow Ochre. FeO(OH). Once defined as a mineral, it is now seen as a mixture of other hydrated iron hydroxide minerals, for example goethite, and often forms as clay or mudstone, producing a solid yellow when crushed. One subset of Yellow Ochre is Sienna – which is limonite with a small amount of manganese (less than 5%) making it darker in color.

Both Sienna and Umber can be heated, and through the process of dehydration some of the limonite present is transformed into hematite, which darkens both materials creating Burnt Sienna and Burnt Umber (see below).

Hematite – Red Ochre. Fe_2O. Hematite is an anhydrous iron oxide, meaning that the crystalline structure contains little to no chemical water. This ochre is responsible for strong reds historically used for paints and stains because of its quick drying time and resistance to sun damage.

Goethite – FeO(OH). Goethite is a partly hydrated iron oxide that produces a strong brown ochre. It is a by-product of the weathering of other iron-rich minerals, which means it is easily found at the surface.

Umber – Primarily goethite, which contains 5–20% manganese, producing a strong brown tone.

Laterite – Not necessarily an ochre, but used in similar practices. Hydrated iron-manganese-aluminum ore is formed through an iron substitution into an alumino-silicate which then sees the silica leach out over time. If the aluminum content is above 50%, it is often classified as bauxite. Used as a colorant, especially when looking for a strong iron response in reducing cooling atmospheres.

Deposits of ochre are most often found in places of aerobic natural weathering or geothermal activity, where the breakdown of ferrous-rich rocks by water creates a precipitation of iron-rich deposits on the surrounding rock layers. These iron-rich minerals saturate clay and calcium deposits, creating what we see as ochre materials.

Soil horizons

The process of soil formation generally involves the downward movement of clay, water, and dissolved ions, and a typical result of that is the development of chemically and texturally different layers known as soil horizons. The typically developed soil horizons, as illustrated in the image opposite, are:

O – the layer of organic matter

A – the layer of partially decayed organic matter mixed with mineral material

B – the layer of accumulation of clay, iron, and other elements from the overlying soil

C – the layer of incomplete weathering, usually consisting of the parent rock from which the clays in the B Horizon are formed

It is essential to understand how clays are commonly situated in a traditional soil horizon. In most cases where high levels of erosion occur, and these layers become exposed at the surface, clays are more likely to be encountered in layers between B and C. Clay deposits covered over by horizon layer A will continue to degrade and become more plastic as acids attack them in the soil. In areas where the horizon layers are disrupted, either by natural forces or man-made (e.g., roadcuts on the side of a highway), weathering will often relocate fine clay materials, exposing them further to the process of

erosion. In fact, human activity via earthworks will create situations where erosion of rock and clayey soils takes place in a short frame of time where it usually would take thousands of years. These horizons will fluctuate depending on the parent rocks associated with horizon C and the ambient temperatures during seasonal changes in the weather. Tropical climates tend to see more substantial weathering between horizons A and B because the warmer climates promote higher acidity in the soils.

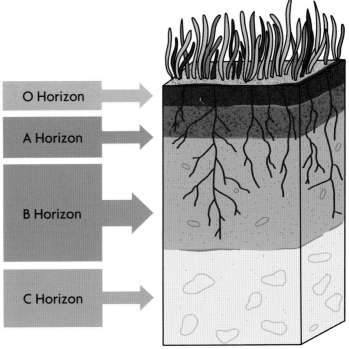

Diagram of soil horizons showing delineations between the different soil types as one moves "up" from the parent rocks to increasingly weathered materials consisting of various minerals, oxides, and organic matter.

FINDING CLAY

Matt Levy

Legalities of Sourcing Clay and Minerals

As far as the United States is concerned, simply put: all clay and other materials are treated as being owned by a person or entity in the American legal system. Nothing exists that is completely "unowned" as a legal concept. Even in cases where no specific person or group has ownership of the clay or minerals, or the property on which said clays or minerals are found, federal, state, or local governments have what is considered default ownership of any and all clays and or minerals located on that property.

In most cases, the ownership of specific clay beds located on the surface follows the ownership of the land upon which those clays are located, so that the person who owns the land also owns these materials.

In some instances, the right of possession for deposits of clay and/or other minerals is transferred to another person or organization. For example, the landowner may lease or place a conservation easement on a specific piece of land, transferring the right to collect and, therefore, control exposed deposits of clay and other materials to a non-profit organization (schools, clubs, etc.). The non-profit organization would have the legal right to the clay.

In other situations, when specific deposits of clay are not located on the surface of a property or comprise specific, identifiable minerals, the possessor of a legal interest, oftentimes referred to as a mineral or clay interest, owns those materials. An example of this would be a brick making company that leases multiple sources of clay, excavated from different properties. The original owner controls the property itself, but the brick company owns the mineral rights of any materials taken from the area.

Even the permission of the land owner to trespass on their property does not convey the right to collect materials like clay from the area. There are many examples of people being criminally charged or even sued for trespassing on private property and taking clay and/or other materials. The laws that apply to rock collecting also apply to clay and other natural materials, so you should never assume that anything is free for the taking. While property lines and possession rights might seem cut and dried, especially in the age of GPS and Google Maps, it

Shigeji Suzuki digging clay at Nakazato Studio, Shigaraki.
Photo courtesy of Nancy Fuller

Kaolin beds in Redwood Falls, MN. Derived from a pink granite found in the area, much of the primary clay deposit is mixed with rough silica and feldspar chips. Photo courtesy of Matt Levy

managed by the Bureau of Land Management (BLM) is permissible if they "do not cause significant surface disturbance" – 36 CFR 228.4a(1)(iv). In instances where collecting clay on public property is substantial, a notice of intent and a plan of operation must be filed with the BLM and the proper permits must be pulled.

Often it is best to work with land owners and obtain permission to dig on private property. Even in these situations, removing clay and other materials can be illegal. A great example of this is the story of the T-rex known as "Sue," that now sits in the Field Museum in Chicago. Originally removed from tribal land in South Dakota, the fossil remains were ultimately controversial because the land was "in trust" and the owner had no right to sell the T-rex's remains without government permission – something that was not known by the landowner at the time. Knowing the distinctions between federal, state, and local laws is crucial to staying out of trouble, but can be even more important in certain parts of the world. Transporting soil and clay across borders and into different countries is often illegal without proper documentation. Make sure to do your research, and understand where you are digging.

is always best to obtain written permission before attempting to collect clay and other natural materials.

Having said that, some States directly address collecting minerals and clay and therefore have laws and variances in place. The difference between collecting rocks and clay can get murky but it is generally stated that collecting rocks, minerals, and clay from land

Collecting clay in North Saint Paul, MN. These secondary deposits dot the upper banks of the Mississippi River. Any clay prospector should always be looking for opportunities to acquire clays from construction sites. Connecting with excavation companies in your area can yield fruitful results. Photo courtesy of Matt Levy

The importance of place

There should always be a plan. You should take a common-sense approach, focusing on the spaces where clays are either made or transported via erosion. To do this, you need to have a basic understanding of the geology in the area where you intend to go prospecting. The potential for viable clay sources often corresponds directly to the surrounding rocks in the area. In many ways, locally sourced clays and minerals directly reflect the landscapes we live in.

While it's true that some areas are more likely to have clay deposits that are easier to reach, given the accessibility of rivers and streams and other waterways, developing an "eye" for clay becomes essential. The ability to see clay in the surrounding geography is acquired over time, and I often compare it to looking for mushrooms: to actually find what you're looking for is the best way to see it, but you must be in the right place. If I'm in a new area looking for potential deposits, I will start by visiting sites where clay is historically known to exist. Clay is the by-product of the earth's erosional forces, brought about by weathering, geothermal activity, and soil acidification, so identifying areas in the surrounding landscape where these events are currently happening or have taken place in the past is essential. Breaking this down further, it's best to oversimplify clay deposits into two groups: Primary and Secondary.

Primary clays or *in situ* are often characterized as deposits that are created in place, meaning that the parent rock weathered or was broken down in the location where it is found. Kaolin is an excellent example of a primary clay, where granite or granite-like rocks decompose over time, often through geothermal activity. The feldspar minerals within the rock break down into kaolin through a process called kaolinization.

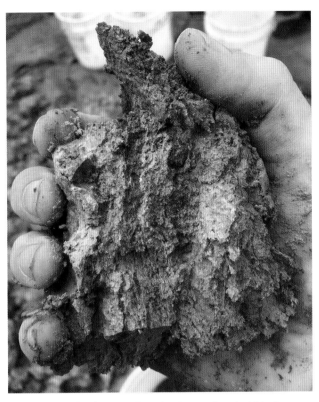

A prime example of a secondary clay deposit found within the outer banks of the Mississippi River in Saint Paul, MN. Note the alternating layers of color in the clay. Photo courtesy of Matt Levy

Primary clays are often coarser and free of or have limited amounts of impurities like iron, burning off to a buff or off-white color. Clays from this group are harder to work with and are considered to lack the plasticity found in secondary clay deposits. Traditionally any rock, even with trace amounts of feldspar, can weather into clay given the correct number of forces and time.

Secondary clays are characterized by deposition through transport; in other words, they are taken from their primary location via wind and water (or glaciation). A mechanical action takes place where clay materials are not only sorted by particle size utilizing the process of levigation but are also introduced to impurities like iron, manganese, calcium, and titanium, respectively.

Primary kaolin deposit north of Helena, Montana. A coarse clay derived from weathered rhyolite, the deposit was turned up during the grading of a backroad, making it easily accessible. Photo courtesy of Matt Levy

These impurities impact plasticity, color, and the melting temperature of the clays. Ball clays, earthenware, and other iron-rich clay sources are most often the by-product of these erosional forces. In Minnesota, most of the clays found in the state and other northern areas of the US were formed by glaciers and glacial melt. Glaciers once covered much of the state as recently as 10–12,000 years ago. Clays made by glaciers often show stratification or layering of different materials, including rocks and sand. Depending on the type of parent rock layers encountered by glacial forces, these boulder clays can range from red (igneous/volcanic rock groups) to blue/gray (Carboniferous period) clays containing calcium carbonate from limestone deposits. Boulder clays, along with the surrounding glacial till, will usually contain large rocks. These rocks are often rounded by the glacier's erosional forces and can help identify the parent material types that went into the clay's creation.

Sourcing guides, books, and internet resources

In the internet age there are many ways to research viable sources of easily obtainable clay deposits in the US, including USGS databases, DNR resources, and State Data on agriculture and soil analysis. Rather than venturing out into the landscape blindly, it's essential to look for information that specialists and scientists have already gathered. In many areas across the continental US, extensive data has been collected regarding clay deposits, especially kaolin and other clays that have viability in commercial industries. Along with understanding the fundamental ways clays are formed through erosion and deposition, a clay prospector can cut search times drastically by starting in areas prone to containing clay and clayey soils. Changes in topography in river valleys, such as places where water channels tighten or narrow and then open up, are prime contenders for substantial deposits

of suitable clays. Any area where strong erosional forces are prevalent, whether natural or manufactured, can yield promising sources of clays and other materials. In the US, roadcuts often expose the local geology and offer great insight into an area's viable resources. One group of texts is the Roadside Geology series by Mountain Press Publishing, which are separated into states and can help clay-seekers find clay sources close to accessible areas or help locate bodies of rock like granites, where weathering might be occurring and clays could be found. It is important to remember that while finding clay is the primary focus, getting back to your car, let alone your studio, will quickly dictate how successful prospecting really is. The benefit of the Roadside Geology books is that most of the sites listed are directly off a main highway or road, making gathering materials much more manageable.

As with most things, having a community element involved can save you a substantial amount of time. There are people such as farmers and construction companies who work with the land daily and can be a tremendous asset when looking for good clay sources. These individuals often see clay every day and think nothing of it because the context isn't there. Once, while helping a former professor put on a clay "workshop" at a local elementary school, we were approached by one of the children's parents. The father was a man who ran a backhoe for a local construction company, digging out large areas of land, prepping foundation sites for future houses in and around Bozeman. He had never even considered that the clay he extracted from the earth daily had any value until he saw firsthand the joy that playing with clay had brought to his child. After the workshop, he started showing us maps on his phone of areas where vast swaths of clay veins could be found just outside of town.

There is no need to seek out clay in solitude, relying alone on personal information and research. Engaging with the community and creating connections is just as vital

because one must remember that the final outcome is that you are taking from the land. Working with people like farmers, ranchers, and construction companies can yield excellent results, where all parties involved profit: they get rid of materials they would otherwise have to move or dispose of themselves, and you acquire as much clay as you can possibly carry back to your home or studio. Having permission to access a clay deposit is as important as knowing its location, especially on private property. Often, a clay source has more value to a potter than it ever will to the person extracting it from the ground. These situations can provide you with an opportunity to share with others the inherent value of clay. I have on several occasions returned to a property bearing gifts: pieces of pottery made from the same materials I gathered from that person's land. These pieces serve as a literal connection to the landscape and carry special meaning to the landowner as they too feel connected to the ground beneath their feet.

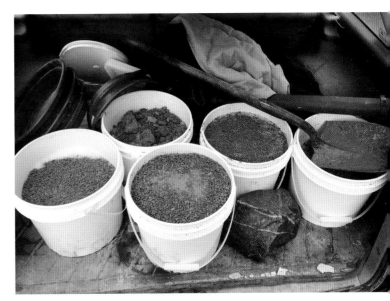

A stoneware clay deposit collected near Bridger Canyon just outside of Bozeman, MT. My car kit for digging clay consists of 25-liter (five-gallon) buckets, plastic mining sieves for removing coarse material, and a shovel. I often look for viable sources of clay in roadcuts. Photo courtesy of Matt Levy

Gathering materials: where to look for clay

On-site testing and analysis: While there are innumerable varieties of clay found across this planet, very few meet all the requirements needed for a workable, plastic clay body. Testing a newly found clay on site is just as important as the testing done in the studio. Shrinkage and water absorption tests will ultimately tell you the actual viability of a clay body, but gauging the usefulness of clay on site is equally important. It will save you the headache of digging and hauling clay, only to find that it lacks the necessary plasticity or contains too much sand. Other inclusions like lime and salt can also make clay useless for producing ceramics, as these minerals will inevitably create defects later on. Doing on-site analysis can help you weed out bad clays and is easy to do with few tools necessary.

The "ribbon test" is a quick way to test for plasticity and should be the first thing you look for in any found clay. Simply wet a small amount of clay and mix it to a consistency that allows you to roll a ball in your hands. Next, roll the clay back and forth between your palms, looking at how easily it forms into a thin coil. If the clay is already cracking and splitting as you roll it out, it will become clear that the source clay either lacks plasticity or contains a large amount of sand. If the clay maintains its integrity, the next step is to start pinching it, starting from one end and gradually flattening it. The end result is a "ribbon" that you should be able to wrap around your finger without seeing any signs of cracking. This simple plasticity test will help you determine if the clay source will be good for making pottery.

If the clay source is dry and can be separated using a small sieve to sort out different particle sizes, it helps to see how much sand and other particulates are present in the clay. A big issue to look out for is the presence of lime or calcium chips. If limestone is present in the surrounding geology of the area, then it is safe to assume that there will be small pieces of calcium carbonate

in the clay. These lime chips can wreak havoc on your finished pots, going unseen until the work is fired to ceramic temperatures. Once fired, the lime chips rehydrate as they absorb moisture from the surrounding area and begin to expand. If "lime pops" are present, you'll notice them as pieces of your pottery start to pop off, exposing the lime beneath the surface. Using hydrochloric acid to test the clay for lime is an easy way to determine if there will be problems later on. Vinegar is also a good substitute if you can't find the acid, but it is not as effective. Essentially if there is calcium present in the clay the hydrochloric acid will cause the calcium to bubble and foam. Screening the clay with a fine sieve – 50 mesh will do – can also expose the lime pops, which will reveal themselves as small white chips.

Another issue with sourcing wild clays in areas close to saltwater bodies is the impact of salts on the clay. This is unfortunate because the erosional forces of

Two secondary clays collected in Saint Paul, MN. Decorah Shale on the left, Boulder clay on the right. A ribbon test shows that only the boulder clay is plastic enough to be workable; the Decorah Shale cracks and will need additional plastic materials. Photo courtesy of Matt Levy

the world's oceans do a fantastic job of exposing vast swaths of clay that are often very accessible from a beach and visible for miles around. Any salt present in clays will come to the surface during drying and will have a negative impact on the pottery as sodium is a powerful flux and will cause the pots to bloat and melt prematurely during the firing. In some cases, it is possible to remove the salts from the clay, but the process is tedious and not worth the effort unless done on a large scale. Testing for salt is done by firing samples of found clays, but it is easy to assume that clays contain residual salts if they are located near bodies of water or fresh waterways where tides can move saltwater upstream.

There will be instances where the joy of finding clay quickly turns to disappointment as you realize that the found clay doesn't have all the necessary qualities that make it viable for producing a quality clay body. In these situations, it's best to collect a sample for future testing and move on. Getting carried away and hauling away buckets of clay only to find that the material is a lost cause will discourage you and others from sourcing materials.

Tools for success: equipment for any occasion

There are several essential tools if one wants to go prospecting for wild clays. Aside from the obvious tools like shovels, bags, and buckets, other things like soil color charts, hydrochloric acid (used for testing for calcium carbonate), and sieves can help with the on-site analysis and save you time upfront. There are other valuable tools; often borrowed from their primary function in the garden as they serve equally well out in the landscape. It is best to find light tools, easily carried in a backpack or belt loop, since it is not always possible to find clay right at the side of the road. Plastic buckets are great for storage and can be carried with ease when empty, but once filled they are pretty heavy and can be tough to haul

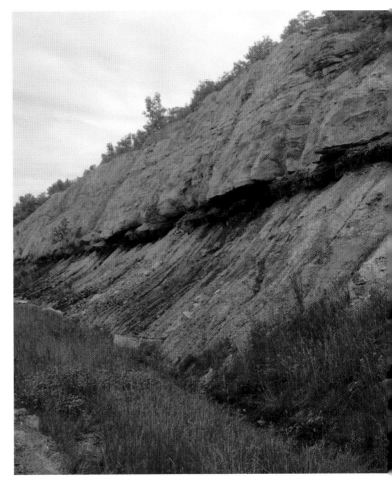

A photo by Steve Blankenbeker, showing prominent outcropping along US Route 33 near Nelsonville, OH.

back to your car. If I know I'll be walking a considerable distance to look for clay, I'll bring thick plastic clay bags and a hiking backpack. It is easier to fill the plastic bags with clay and carry them in the backpack since the load can be carried on my shoulder, close to my center of gravity. In this way, having compact or compactable tools – like a folding shovel – becomes invaluable. Another thing to remember is that the wetter the clay is, the heavier it becomes and the less material you can realistically bring back – you want the clay, not the water.

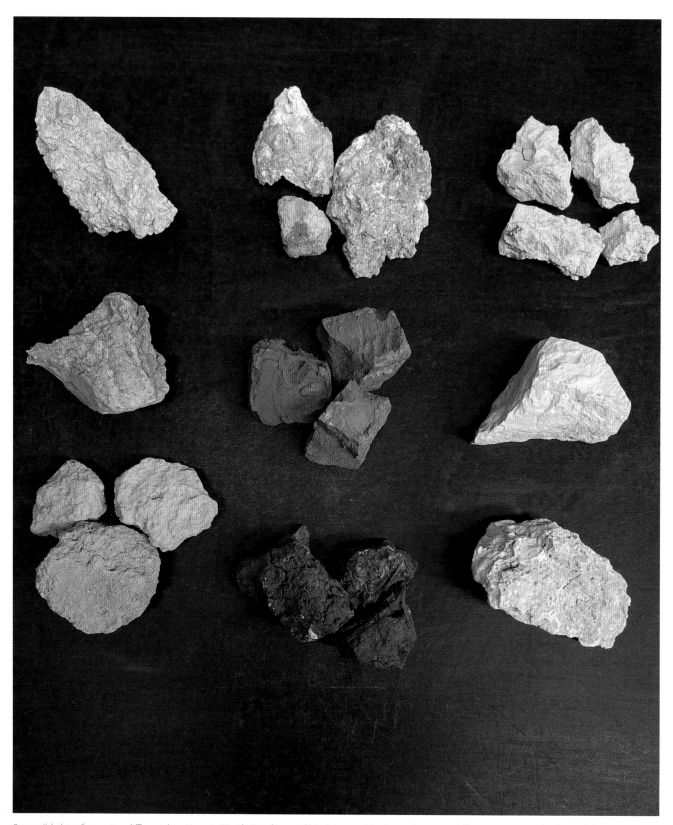

Raw wild clays from nine different locations in North Carolina and Virginia, straight from the ground. Photo courtesy of Takuro Shibata

PROCESSING AND TESTING WILD CLAY

Takuro Shibata

TESTING WILD CLAYS

In order to use any clay, it must first be tested.

Preparing for testing

Thoroughly drying the clay will speed water absorption and slaking. If the clay is easily broken by hand, simply add water before shaping into test tiles. If, however, it is difficult to break, it may not absorb water readily. Crushing it with a hammer may be helpful in this case.

Clay made into slip and left in a glass container overnight should settle, leaving a layer of clear water on top. If it does not settle, a small amount of flocculant should make the clay and water separate, which will speed drying and counteract any tendency toward thixotropy.

Dry the clay slip to a workable consistency on plaster or bisque bowls with cloth, then knead it prior to making test bars and glaze test tiles for testing shrinkages, water absorption and glaze fit. See p. 65 (top photo) for an example of clay test tiles and glaze test tiles. Roll out slabs and cut them to size to make test tiles.

Crushing the wild clay with a hammer into small pieces.
Photo courtesy of Hitomi Shibata

Creating a test tile from the raw clay. Photo courtesy of Takuro Shibata

Using molds to make tiles is another possibility. Tiles that are approximately 4 inches (11 cm) x 1 inch (2.5 cm) x 0.5 inch (1 cm), inscribed accurately with 100 mm marks will make it easy to quickly determine shrinkage.

1. Plasticity

Check and see if you can make clay coils and wrap them around your finger. Less cracking and breaking indicate the clay is more plastic. See opposite (top) for examples.

2. Percentage of water in the clay

To determine the percentage of water in the clay, weigh the clay tiles in the plastic state, and weigh them again after drying.

Subtracting the dry tile weight from the wet tile weight will indicate the amount of water lost in drying. This may be expressed as a percentage by dividing the amount of water lost by the wet tile weight, and multiplying by 100.

For example: if the wet tile weighs 90 grams and the water lost in drying is 10 grams, then (10/90) x 100 gives 11.11% as the percentage of water lost in drying.

3. Dry shrinkage

Shrinkage is determined in an analogous fashion. Measuring the mark that was originally 100 mm long on the fresh clay will show how much the clay has shrunk in drying. This may be expressed as a percentage by dividing the amount of shrinkage by the original length and multiplying by 100.

Using a mark measuring 100 mm gives an easy answer, as the percentage can be read directly by comparing the mark on the dry tile to a 100 mm rule. For example, if the dry length is 95 mm, it shows that the tile has shrunk by 5 mm, and thus (5/100) x 100 gives 5% wet-to-dry shrinkage.

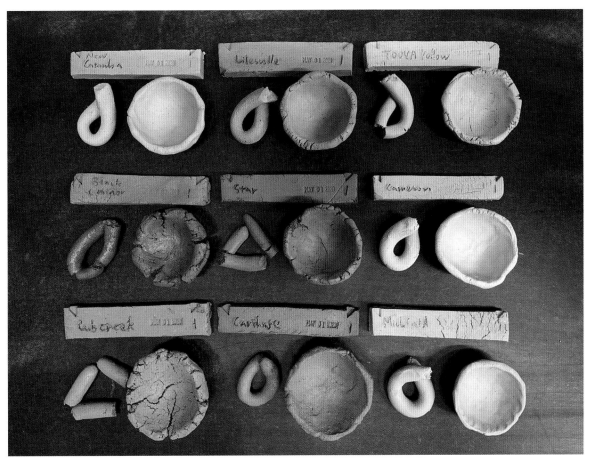

Raw wild clays from nine different locations in North Carolina and Virginia, partially processed to create test tiles, coils, and pinch pots for the glaze test. Photo courtesy of Takuro Shibata

Close-up of raw wild clays from North Carolina and Virginia. Photo courtesy of Takuro Shibata

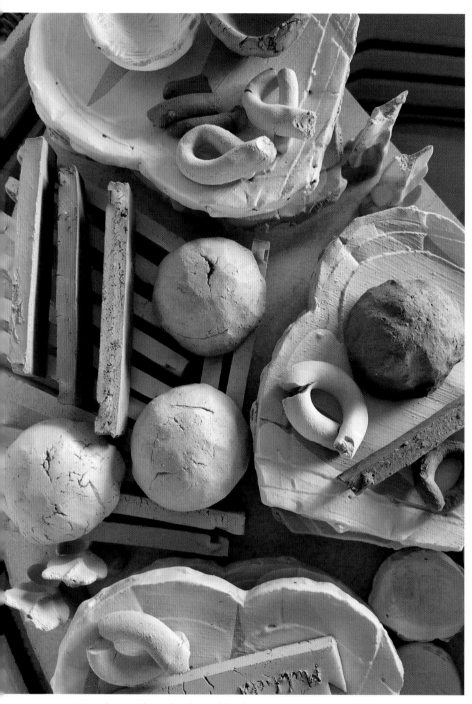

Firing the test tiles in the electric kiln. Photo courtesy of Takuro Shibata

4. Firing the test tiles

The next step is to fire the test tiles in a kiln at increasingly higher temperatures. Cones 04, 06, and 10, for example, might be good choices. The electric kiln would typically be fired in an oxidation atmosphere, whereas fuel-fired kilns that can be fired in a reduction atmosphere will reveal different clay characteristics with differing colors and degrees of vitrification.

Test tiles should be fired at lower temperatures first. It is always a good idea to fire them on bisque plates or bowls to contain any melt that might occur.

5. Testing glaze fit on your clay

A quick way to check thermal expansion is to use known glazes on bisque tiles you have prepared. Greenware tiles may work, but bisque tiles are safer. Using two different glazes with different thermal expansions (high and low) will give you some indication if the glazes either craze or shiver.

6. Firing shrinkage

Firing shrinkage is measured in the same fashion as wet-to-dry shrinkage. Measuring the mark that was 100 mm long on the fresh clay will show how much the clay shrinks in drying and firing.

For example: If the fired length is 88 mm, then the tile has shrunk by 12 mm, and thus (12/100) x 100 gives 12% wet-to-fired shrinkage.

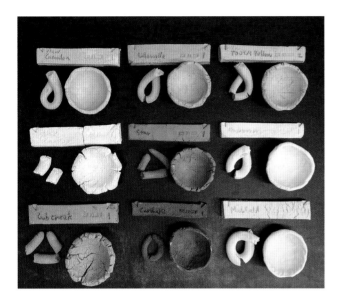

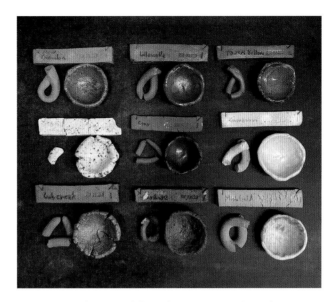

Raw wild clays from nine different locations in North Carolina and Virginia, after firing Cone 09, 1683°F (917°C). Photo courtesy of Takuro Shibata

Raw wild clays from nine different locations in North Carolina and Virginia, after wood firing at Cone 10, 2340°F (1282°C). Photo courtesy of Takuro Shibata

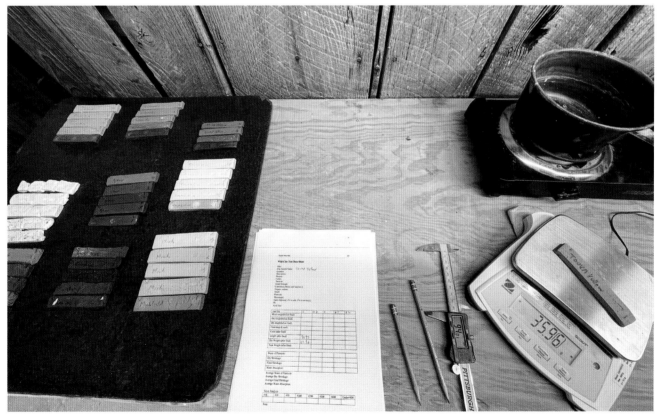

Checking the length and weight of the fired test tiles. Photo courtesy of Takuro Shibata

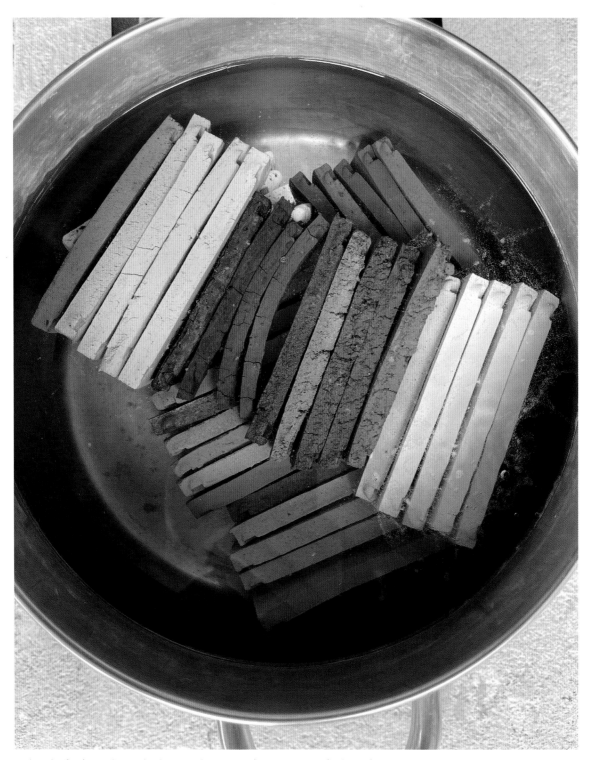

Boiling the fired test tiles to check water absorption. Photo courtesy of Takuro Shibata

7. Water absorption

Apparent porosity may be determined by measuring the water absorption after firing.

Measure and record the weight of the fired tiles (dry weight or DW).

Boil the tiles in water for five hours and allow them to soak for another 24 hours. Make certain that the tiles are covered with water all the time.

Remove the tiles from the water, wipe with a clean cloth, then measure and record the weight again (wet weight or WW).

The difference between the dry weight and the wet weight is the amount of water absorbed. This number divided by the initial dry weight gives the percent of absorption.

For example: If the dry weight is 50 grams and the wet weight is 55 grams, then the tile has absorbed 5 grams of water. This number divided by the initial dry weight and multiplied by 100 gives absorption expressed as a percentage, so (5/50) x 100 gives an absorption of 10%.

There are individual variations between tiles, so the best practice is to use two or more tiles from the same clay, fire them side by side, and calculate the average.

8. Checking coarse particles in the clay

Using a graduated series of sieves, clay can be screened to determine the size of particulate matter it includes. (A typical range might include 10, 16, 20, 30, 50, 80, 100, 200, 300, and 400-mesh sieves.)

Because clay minerals are typically less than two microns (0.000079 inch [0.002 mm]) and thus much smaller than the openings in a 400-mesh sieve which measures 37 microns (0.0015 inch [0.04mm]) across, not everything that passes through this finest of sieves will be a clay mineral, but this process will indicate the particle size distribution of the coarser materials included.

To facilitate data records, examples of blank data sheets are included at the end of the book.

A series of sieves. Photo courtesy of Takuro Shibata

Nine different North Carolina and Virginia wild clays

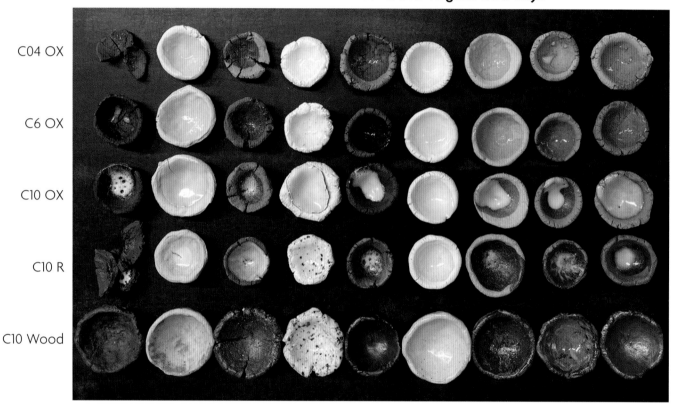

C04 OX

C6 OX

C10 OX

C10 R

C10 Wood

The same raw wild clays from nine different locations in North Carolina and Virginia, fired at different temperatures with glaze to see the fit. The columns are the nine different clays, and each row down shows the different temperatures: C04 OX, C6 OX, C10 OX, C10 R, C10 wood fired. Photo courtesy of Takuro Shibata

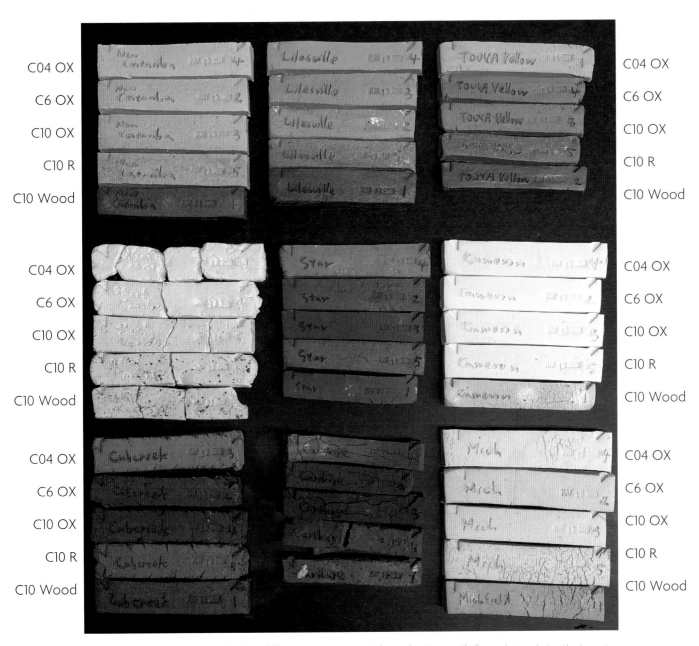

Each of the nine different clays fired at different temperatures without glaze in test tile form, the top being the lowest and the bottom being the highest for each clay. From top to bottom: C04 OX, C6 OX, C10 OX, C10 R, C10 wood fired. Photo courtesy of Takuro Shibata

Touya Yellow

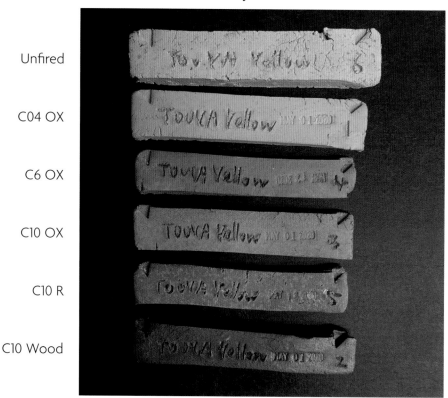

Unfired

C04 OX

C6 OX

C10 OX

C10 R

C10 Wood

Example of wild clay. Touya Yellow is the yellow clay that we found when we built our kiln shed. The top row is unfired and the bottom was fired at the highest temperature for each clay. From top to bottom: unfired, C04 OX, C6 OX, C10 OX, C10 R, C10 wood fired. Photo courtesy of Takuro Shibata

Example of wild clay: Touya Yellow

We found some beautiful yellow wild clay when we dug the foundation of our kiln. Hitomi and I call it "Touya Yellow." We dug down about 1 ft (30 cm) to hit the yellow clay under the topsoil. Our property is located in the historic Seagrove area and we knew of yellow clays from our neighbors, but we didn't know that clay was under our feet. We dug in some different areas on our property by hand, but we found this yellow clay only around our kiln shed.

According to the testing results, I found that the yellow clay has its own unique characteristics. The water absorption at Cone 10 gas reduction firing and Cone 10 wood firing are less than 2%, and shrinkage is approximately 12%. These are the ideal numbers for functional pottery to be able to hold water without leaking and to avoid cracking.

When I examined the test results, I noticed that Cone 10 wood firing shrinkage is less than Cone 10 gas reduction firing shrinkage, which does not seem to be right, but this is the actual number that I got from this test. It is always good to make multiple tiles and take the average measurement, instead of just making one test tile.

We use this yellow clay as a slip for decorating on pottery and also in the clay bodies. In this section, we would like to share the testing results, as one of the examples.

		Dry length (mm)	Wet weight (g)	Dry weight (g)	Shrinkage (%)	Water in the clay (%)
Touya Yellow	Raw	95.58	61.03	51.43	4.42	15.73

	Firing temp.	Length (mm)	Dry weight (g)	Wet weight (g)	Shrinkage (%)	Water absorption (%)
Touya Yellow	C04OX	93.97	35.96	43.76	6.03	21.69
Touya Yellow	C6OX	90.37	30.87	34.43	9.63	11.53
Touya Yellow	C10OX	88.76	33.97	35.85	11.24	5.53
Touya Yellow	C10R	86.67	32.66	33.17	13.33	1.56
Touya Yellow	C10 Wood	87.72	32.34	32.72	12.28	1.18

Example of testing data.

Hitomi Shibata: Wild Clay Platter, made from 100% Touya Yellow clay, wood fired, 13 inches (33 cm) diameter. Photo courtesy of Hitomi Shibata

North Carolina raw wild clay. Photo courtesy of Takuro Shibata

MAKING CLAY BODIES

Takuro Shibata

DEVELOPING STONEWARE CLAY BODIES

Developing a clay body entails mixing clays and other materials to adjust their workability and firing characteristics, including thermal expansion, shrinkage, and maturation temperature. Workability is the physical character of the clay in the plastic state. Workability is complex, and difficult to measure and describe, but physical manipulation, rolling coils, etc., will give some indication. Added to this, measurement of shrinkage – both wet-to-dry shrinkage and fired shrinkage – will reveal much about a given clay body. After firing, water absorption is another important data point, revealing whether it is necessary to adjust the maturation temperature or change the firing temperature. When adjusting one variable, however, other variables like shrinkage, workability, and glaze fit may also be affected, so it may be necessary to circle back, adjusting all of the variables to arrive at a final recipe.

Before developing a clay body, it is important to know about the materials that are available, so the first step is to test all of them. If commercial clays are to be included, these should be tested as well. All of these tests must be completed before mixing a custom clay body.

There are many kinds of clay bodies – sculpture, tile, throwing, hand-building, slab, etc. The scale of the work intended is also an important consideration.

Some typical clay bodies might exhibit these characteristics:

Sculpture and tile bodies
Shrinkage: low
Water absorption: high
Texture: coarse
Plasticity: low

Throwing clay bodies
Shrinkage: high
Water absorption: low
Texture: fine
Plasticity: high

Hand-building and slab bodies
Shrinkage: medium
Water absorption: medium
Texture: medium
Plasticity: medium

Large-scale work with thicker walls is prone to uneven drying and firing. A coarser clay with low shrinkage may help prevent cracks during drying and firing. A greater amount of porosity is often acceptable in sculpture bodies, so water absorption may be somewhat greater than in other kinds of bodies.

The initial tests mentioned above should suggest the suitability of a raw clay for a particular purpose. A refractory clay with a high maturation temperature should probably not be chosen for a low temperature earthenware body. Likewise, a clay with a low maturation point should probably not be chosen for a high temperature body.

It is a lucky potter indeed who finds clay that can be used as it comes from the earth. Most often adjustments must be made. Minimum adjustment is always the best way to preserve the original, unique qualities of a clay.

Step 1. Adjusting workability

The first step is to adjust the workability of the clay.

Plasticity in clay is a necessity, but if clay is too sticky it will be hard to use. This requires the addition of less plastic or non-plastic materials. Typically, this would include things like fireclay, feldspar, talc, pyrophyllite, silica, and grog. This addition will adjust the workability, but will also change the firing properties, so please read step 2 to find out which less plastic or non-plastic materials might be suitable to add to your clay body.

Maximum plasticity is obtained when clay is thoroughly hydrated and aged. Even without aging, a de-airing pug mill will thoroughly mix the water into the clay and remove air, making it denser and increasing its workability.

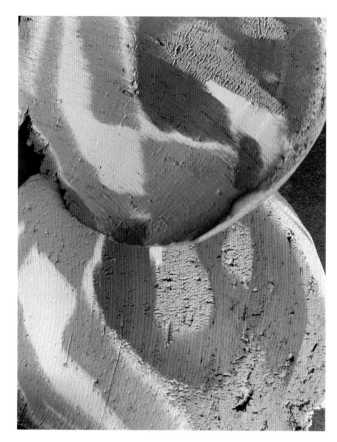

Mixing four different types of wild clay.
Photo courtesy of Takuro Shibata

If it is not plastic enough, clay can be sieved through a fine screen to remove coarser particles. In this way the percentage of fine clay is increased, making it more plastic. In clay mixed as slip and allowed to settle, coarse particles will fall to the bottom, making it possible to take only the top fine clay layer to use. Some clays settle more readily than others. Adding a flocculant such as Epsom salt or magnesium chloride will change the pH. Sodium ions (Na^+) and potassium ions (K^+) will be replaced with magnesium ions (Mg^{2+}) or calcium ions (Ca^{2+}), which will allow the clay to settle more readily. Adjusting the pH in this manner not only makes it easier to separate the finer clay from the coarser materials; it will also further increase the plasticity of the de-watered clay.

If the resulting clay is still not plastic enough, it is possible to add plastic clays or other plasticizers like bentonite.

Sometimes, simply combining clays will increase workability. Mixing two different clays together in equal parts will give some indication of possible beneficial synergy. Some clays work well together, others do not.

Having experimented with two clay combinations, it is, of course, possible to try more complex combinations.

If three clays including commercial clays are available to mix, a triaxial blend is a good way to test workability, and you could also check properties such as color, clay shrinkage, and water absorption. If you test in 20% increments, you will have 21 combinations (see diagram below).

If you do 10% increments you have 66 combinations to test. You also could test the specific area in a smaller number of combinations.

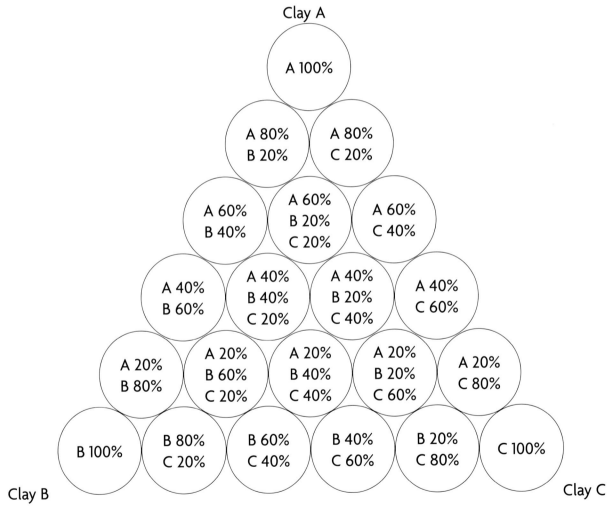

Triaxial blend test with three different clays.

The triaxial blend test with three raw wild clays, before firing. Photo courtesy of Takuro Shibata

The triaxial blend test with three raw wild clays, after firing at Cone 10 OX. Photo courtesy of Takuro Shibata

In wild clay, it will not be necessary to test all possible combinations. In choosing combinations, the properties of each individual clay (color, texture, plasticity, shrinkage, maturation temperature, etc.) will suggest appropriate combinations.

color	• If the body is too light, add red clay. • If the body is too dark, add light clay.
texture	• If the body is too fine, add coarser clay. • If the body is too coarse, add finer clay.
shrinkage	• If the body shrinks too much, add low shrinkage clay. • If the body shrinks too little, add high shrinkage clay.
maturation temperature	• If the body does not mature at the target temperature, add clay that matures at a lower temperature. • If the body is over-fired at the target temperature, add clay that matures at a higher temperature.
plasticity	• If the body is not plastic enough, add plastic clay. • If the body is too plastic, add non-plastic clay.

Commercial clay may prove useful additions to wild clays.

• The addition of ball clay and/or up to 2% bentonite will increase plasticity.

• The addition of more refractory clays, ball clay, fireclay, kaolin, etc., will increase maturation temperature.

• The addition of earthenware clays will decrease the maturation temperature.

The following examples are ways to mix wild clays with the other materials that go into a clay body.

Slip mixing

The best and perhaps easiest way to mix clays together is "slip to slip," that is, mixing two materials already mixed individually with water. It is also possible to add small amounts of dry materials to these mixtures. After mixing, time must be allowed to remove excess water from such a mixture to bring it to a good working consistency. There are a number of ways to accomplish this task, using for example cloth, plaster bats, bisque pots, or a filter press. See photographs below and on p. 80.

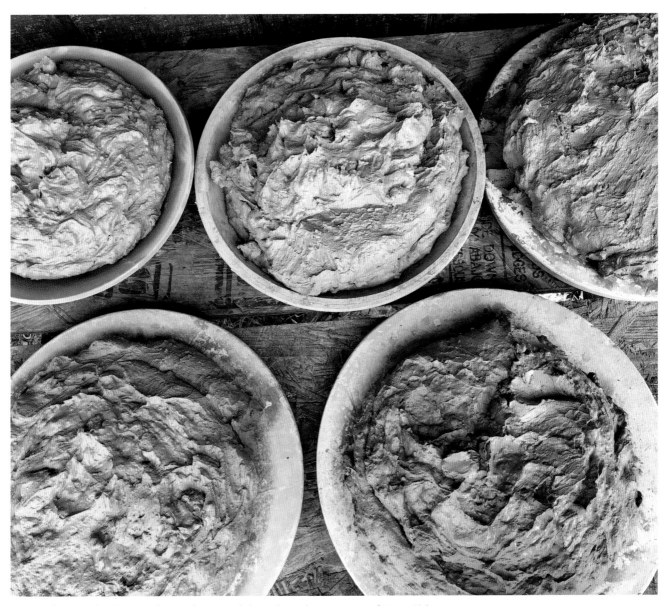

Touya Yellow raw clay, drying on bisque platters and plaster bats. Photo courtesy of Hitomi Shibata

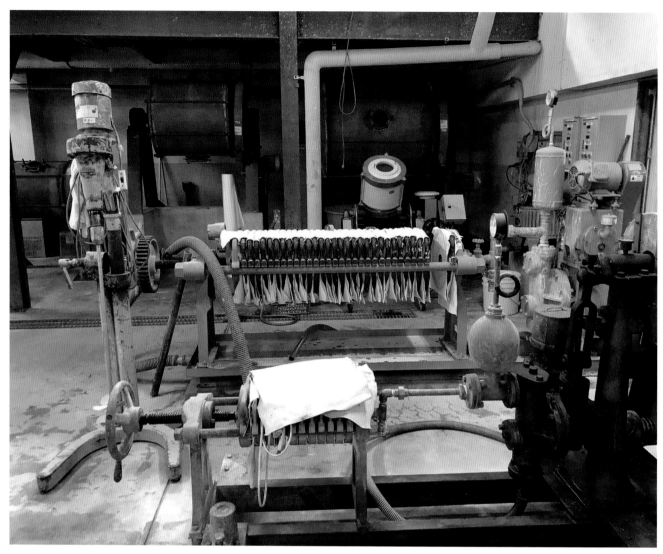

Filter presses at Shigaraki Ceramic Research Institute. Photo courtesy of Hitomi Shibata

Moist clay mixing

It is hard to mix two different moist clays perfectly. It also would be challenging to add fine dry materials into moist clay and thoroughly disperse it. However, it's not hard to mix coarser dry materials like sand or grog into moist clay. When you handle dry fine powder clay, you need to make sure to use a good dust mask and follow safety guidelines.

Step 2. Adjusting shrinkage, maturation temperature, and glaze fit

Having achieved a clay body with good workability, the second step is to adjust the firing range.

This example illustrates the development of a stoneware clay body for functional ware from wild clays.

Clay bodies for functional pottery must be watertight. Stoneware clays for this purpose should have water absorption of between 1–3%, and thermal expansion that allows for good glaze fit. With the exception of porcelain bodies, water absorption of less than 1% often leads to dunting and bloating problems.

For stoneware, a water absorption rate of greater than 3% requires adjustment to decrease absorption. A typical approach would be to add feldspar, talc, or lower temperature clay to increase vitrification.

1. Adding feldspar

Add feldspar in 5% increments up to 20% and observe how water absorption changes. Feldspar also may remedy glaze fit issues such as shivering.

2. Adding talc

If feldspar does not sufficiently decrease water absorption, the addition of talc may prove useful. Talc acts as a strong flux in stoneware clay bodies, so 1–3% should be sufficient.

3. Adding lower temperature clays

Because some clays mature at a lower temperature than others, adding these may serve to increase the vitrification and decrease water absorption.

4. Adding silica

Any of these adjustments to decrease water absorption may also affect glaze fit. If the glaze crazes, the addition of 200-mesh silica may prove useful. Small amounts, from 2–10%, are often sufficient to stop crazing. The addition of silica, however, may also affect water absorption, so it may be necessary to re-adjust the feldspar addition.

Test pieces fired at Cone 10 in Shibata's wood kiln in Seagrove, NC. Photo by Takuro Shibata

5. Adjusting shrinkage

Typical wet-to-fired shrinkage varies with application.

- Throwing bodies 10–12%
- Tile and hand-building bodies 8–10%
- Large-scale sculpture bodies 5–8%

The addition of coarser materials such as grog, mullite, and sand will reduce shrinkage and warping. These materials are available in different mesh sizes. The total percentage

of coarse material added is, of course, important, but particle size distribution will also influence workability. Coarser mesh sizes are more effective in reducing shrinkage, but they can also increase water absorption and negatively affect throwing, trimming, and carving qualities. If your clay is not plastic enough, adding an excess amount of coarse materials may increase the cracking.

Porcelain clay bodies are somewhat different from stoneware clay bodies. If naturally occurring kaolin is available, it would be possible to develop a porcelain clay body. A typical starting point for Cone 10 porcelain would be 40% kaolin, 20% silica, 20% feldspar, and 10% plastic clay. If plastic kaolin is available that would be ideal. Otherwise, ball clay will serve as plastic clay. If necessary a small amount of a plasticizer such as white bentonite may prove helpful. Water absorption of porcelain can be close to 0%, but the firing range is narrow. If over-fired, porcelain will melt, so careful testing is imperative.

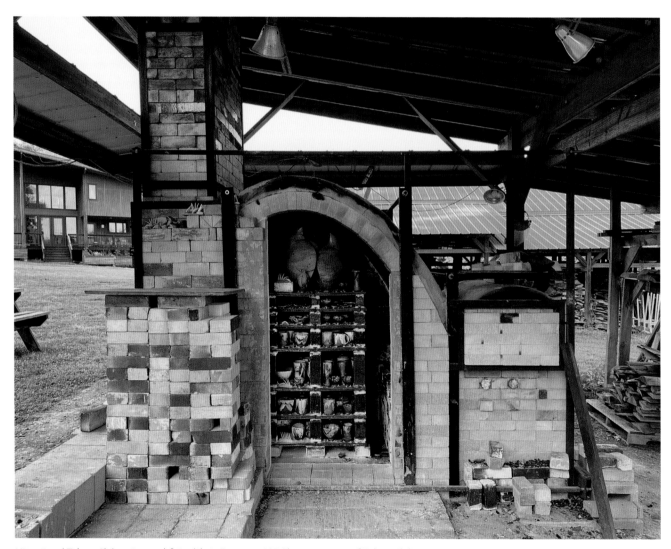

Hitomi and Takuro Shibata's wood-firing kiln in Seagrove, NC. Photo courtesy of Takuro Shibata

Troubleshooting

Problem	Cause	Corrective action
Water seepage	Water seepage occurs when the clay is insufficiently vitrified.	Decrease firing speed and/or increase top firing temperature.
		Adjust the clay body to increase vitrification.
Warping	Warping occurs when the clay thickness is uneven or when the clay has been subject to uneven pressure, uneven drying, or has been over-fired.	Rethink the making and drying process to eliminate unevenness.
		Check the water absorption and decrease firing temperature if absorption is too low.
		Adjust the clay body to decrease shrinkage and vitrification.
Bloating	Bloating occurs when the materials in the clay decompose, creating gas that is trapped in the body.	Decrease firing speed and/or temperature.
		Screen the clay to eliminate coarser materials prone to decomposition.
		Decrease bisque firing speed and/or bisque to a higher temperature. Make certain that the bisque atmosphere is strongly oxidizing to eliminate all organic matter and decomposition gasses.
Drying cracks	Drying cracks occur when the clay dries unevenly.	Decrease drying speed, eliminate drafts.
		Check the drying shrinkage; adjust the clay body to decrease wet-to-dry shrinkage if necessary.
Dunting or cooling cracks – hairline cracks with sharp edges	These cracks occur when cooling too fast and/or when the body is over-fired.	Decrease cooling speed.
		Check the water absorption; decrease firing temperature if absorption is too low or adjust the clay body to accommodate a higher top-firing temperature.
Firing cracks – wide cracks with uneven edges	These cracks occur when the temperature increases too quickly.	Decrease firing speed, especially around quartz inversion temperature 1063°F (573°C).
Firing cracks – wide cracks with sharp glaze edges	Thermal expansion differences between body and glaze can cause ware to pull itself apart.	Reformulate clay body and/or glaze to adjust thermal expansion. Minor differences may be accommodated by applying glaze to both inside and outside of ware to be fired.

A small basket dipped in an iron/manganese-rich clay slip and wood fired. Slips are ideal for wood and salt/soda firings where fluxes in the atmosphere create dynamic contrasts on the slips' surface. Photo courtesy of Matt Levy

GLAZES, SLIPS, AND ALTERNATIVE PRACTICES

Matt Levy

Given the immense variety of clays found throughout the known world, some are better than others when producing viable clay bodies. While some areas of the US, like the slate belts of the southeast, possess vast deposits of plastic kaolin, fire, and ball clays, other parts of the country, like Northern Minnesota and Wisconsin, sit on clay beds of earthenware formed along the coasts of Lake Superior as well as beds of weathered pink granites producing kaolin in the southern part of the state.

More often than not, finding clay in a roadside embankment or your backyard is just the beginning. Suppose it turns out that your material either lacks the plasticity needed to be useful for making pottery or needs more processing than it's worth, yielding little clay. In that case, there are other ways to include found clays in your artistic endeavors. Often using found clays as surface decoration over commercial clay bodies is a great way to incorporate a personal touch without compromising function or needing to amass a large amount of material. These decorative effects can also help reference the landscape from which the materials came, creating exciting dialogues between the art you make and the land.

Slips

In its most simple iteration, a slip is a mixture of clay and water. I find that slips derived from raw clays are the best and easiest way to insert a material into an existing practice. Clays that are not fit to be used in clay bodies due to lack of plasticity or the unwanted inclusion of impurities can find new life as a vitreous slip applied to greenware. Another advantage of this use is quantity; a bucket of local materials can go a long way if utilized as a slip rather than being made into a small batch of clay. Often, I will sieve a clay in a 60-mesh screen to remove any large particles and do fit tests by dipping greenware tiles in the respective clay slip to see if it will flake off during a bisque firing. Slips with good plasticity can be applied to greenware or bisqueware if there is little to no shrinkage found in the clay. It is essential to test materials, looking for specific outcomes that might testify to the potential of a material.

	Flux (%)	Clay (%)
Whiting	30–40	60–70
Nepheline syenite	20–30	70–80
Wood ash	20–50	50–80
Dolomite	20–30	70–80
Spodumene	20–30	70–80

A simple table that illustrates a starting point for testing local clays as potential glaze materials.

When conducting glaze tests, I'll start by doing what are called "line blends," where I mix a clay with different fluxes like whiting (calcium carbonate), wood ash, and any variety of feldspar. Even when the desired temperature is lower than the traditional high-fire temperature range – 2345 °F (1300 °C) – line blends with frits and local clays can yield interesting results. The chart on the left is a simple starting point for me when doing line blends with found clays. Suppose I have a clay that I know to be high in silica; I will usually start with a feldspar of nepheline syenite, since these fluxes add alumina in addition to sodium and potassium, helping to make a stronger glaze surface. Calcium carbonate is an excellent flux, used historically by the Chinese and Japanese to make various glazes from tenmoku and iron saturate glazes to celadons, where the presence of iron in the clays elicits greens and blues in the glaze. As seen in the chart, doing line blends of calcium carbonate (whiting) and a wild clay can be done

Glazes – A friend once joked that an earthenware clay is just a high fire glaze waiting to happen. There is some truth in that, due to the high levels of fluxes present like iron, calcium, and manganese. Clay plays a significant role in glaze-making, providing the alumina necessary for a strong glaze surface. Still, clays also act as suspenders, helping to keep all the different materials and fluxes in suspension in the glaze bucket. Iron-rich clays can often be the base for celadons and ash glazes, needing only a few additional materials in order to create a strong, functional glaze surface. Often the presence of other minerals like calcium carbonate, titanium, and manganese will create striking surfaces with attractive levels of variety.

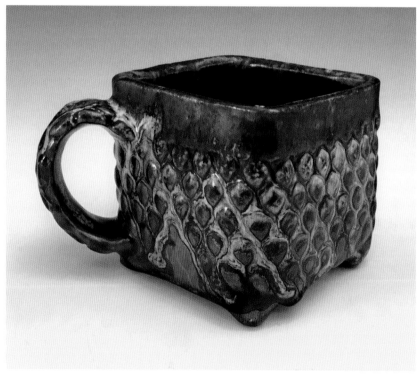

A square-rim mug made by Matt Levy and glazed with a clay/thistle ash/diorite glaze of equal parts (33% each). The clay is a Montana kaolin that helps stiffen the glaze melt but also helps keep the glaze in suspension. Photo courtesy of Matt Levy

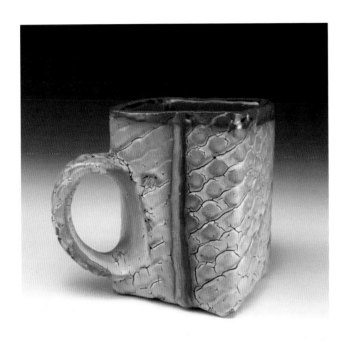

Square-rim cup made by Matt Levy. The soft, toasty orange glaze is a simple mixture of local Seagrove clay and nepheline syenite (70/30%). This ratio is a nice starting point for a local clay slip glaze. Photo courtesy of Matt Levy

in 5–10% increments. Usually, I would make three test tiles starting with 30% whiting and 70% clay; then, the second tile would comprise a mix of 35% whiting to 65% clay; and then a third at 40% whiting to 60% clay. These are simple tests designed to help you understand if your local clay has potential as a glaze or slip component.

There are more complex testing solutions, including tertiary blending with multiple fluxes. Multiple fluxes, oxides, and carbonates are often paired with wild clays to create a wide range of outcomes. A classic combination for me is to use a found clay with wood ash (which adds oxides like potassium and calcium) and a feldspar (containing 10–15% sodium/potassium depending on the type of feldspar rock used). While the traditional ash glaze

recipe is 50/50 ash/clay, adding a feldspar material brings both additional fluxes and also alumina and silica, helping to create a more stable melt and limiting the chance that your glaze will run off the pot. These tests require tertiary blending, named for the triangle diagram (see p. 77) where each material at one corner represents 100% and then descends proportionally in each direction as it is combined with the corresponding materials.

Other artists, such as the Australian potter and educator Dr. Steve Harrison, have written extensively about testing methods that focus on locally sourced materials. Steve has self-published several texts on processing rocks for glaze-making, including his book on ball milling or his in-depth experiences on making rock glazes, utilizing materials found in and around his property in New South Wales in Eastern Australia. For Steve, sourcing materials within a certain radius of his land reflects a personal drive to live a sustainable lifestyle with as tiny a carbon footprint as possible. The materials he incorporates into his pottery directly reflect the landscape surrounding him, where little is wasted. Steve has even incorporated kangaroo bone ash into recipes after finding the remains of an animal on his property. Waste not, want not; this philosophy drives many artists interested in sourcing local materials.

In his book *Rock Glazes Unearthed*, the UK artist and author Matthew Blakely expands on his research into using local clays and rocks sourced from the landscapes of Britain. Matthew's own recently published text is an intensive exploration into utilizing various stones in glaze-making using extensive testing. To quote Matthew: "My aim is to create another way of looking at the land on which we live by making ceramic pieces that are entirely created from rocks and minerals that I have collected from individual locations. Each piece will therefore be an illustration of the ceramic and geological character of that place."

The late Brian Sutherland's book *Glazes from Natural Sources* is another book published in the UK that references sourcing local materials as a way to connect with the landscape. His experiences are also tied to the UK, but while many of his observations might seem limited to specific materials, the overall focus is on incorporating local rocks into one's practice. There is a common theme of self-reliance found in many authors of books pertaining to the use of local clays, promoting a DIY mentality as a means of furthering one's artistic practice and creating unique and personal artistic works.

Two other books that focus on sourcing locally are Miranda Forrest's book *Natural Glazes: Collecting and Making* and the seminal text by the late and great potter Phil Rogers, *Ash Glazes*. These texts encourage the exploration of using plant and wood ashes to create vibrant glazes from found materials. These five potters and writers have done extensive work in sourcing and testing local rocks, clays, and ashes for use in ceramics, so any further words put down here would be a waste, and I encourage you all to seek out these excellent texts.

The amount of material needed to make slips and glazes is minute compared to the hundreds, if not thousands of pounds of clay necessary to make it worth formulating a decent clay body. If one has limited access to resources, consider stretching materials through the use of surface decoration.

Terra Sigillata – Originally a word that referenced a type of earthenware vessel of Roman design, the meaning of *terra sigillata* is "clay bearing little images." In its current and contemporary use by studio potters, the term refers to a fine-particle-sized slip used to seal earthenware pots by burnishing the outside of leather-hard pottery. The build-up of layers of *sigillata*, which are then burnished, creates a vibrant surface that can create a level of impermeability and water resistance

Terra Sigillata
Recipe

A standard recipe for making Sigillata calls for a ratio of 2:1 water: clay (by weight) with the addition of 0.5% deflocculant as per the weight of the clay.

2 parts Water
1 part Dry Clay

when fired to low temperatures. Another great book to acquire if you are looking at exploring the use of *terra sigillata* with raw, local clays is the text by the same name: *Terra Sigillata, Contemporary Techniques* by Rhonda Willers. Rhonda has done extensive research and provides excellent examples of contemporary practices using this ancient process. Ideally, it is best to use clays that have a finer particle size and therefore will be more likely to stay in suspension; however, I have found that adding larger amounts of deflocculant can help bypass any issues encountered with using local clays. Otherwise, crushing the dried clay by hand or running it through a grain mill to create a finer particle size will also help achieve a higher yield of terra sigillata. If the clay is too coarse, then there is less fine material at the top to siphon off, making the whole process too time-consuming for the amount of sigillata obtained in the end.

Alternative practices

Paints and pastels

Clay has long been a favorite binder for making pastels and Conté pigment sticks, with the inherent plasticity of clay allowing the stick to hold its shape after the pastels have dried and hardened. Since the pastel sticks will not be treated with any form of heat, any natural colors and pigments found in the clay have a greater chance of staying intact, including purples, lavender, and bright reds. Many times in the past I have discovered deposits of clays possessing beautiful color ranges, only to be disappointed when I open a kiln to find that my vibrant purple clay has fired to a dull red.

Many of these color responses are due to the presence of iron and manganese in the clays and a reaction to the lack of oxygen present below the surface. Once these materials are fired into ceramic, the iron and manganese react to the oxygen in the kiln atmosphere and oxidize into more muted tones. Because of this, I found myself looking for other alternatives to using clays that didn't require turning the clay into ceramic.

For K. Jodi Gear, a landscape and portrait artist living in Montana, using local pigments and clay binders is an excellent way to incorporate the surrounding landscape into her practice. Montana has an abundance of ochres, various forms of iron, and manganese oxides,

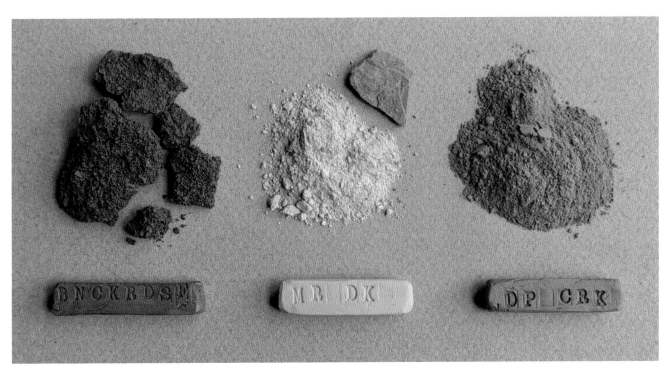

Conté sticks made by K. Jodi Gear show a nice range of colors, several made with local pigments found in Montana. These sticks are durable and can be made by screening local clays like kaolin to remove sand and silt, then combining these other clays, pigments, or oxides to yield stronger color responses. Photo courtesy of K. Jodi Gear

Overleaf top: Powdered pigment clays and their corresponding Conté sticks made by K. Jodi Gear. This is a great alternative when you find yourself with a striking lavender purple or crimson red clay and want to retain the color of the found materials. Photo courtesy of K. Jodi Gear

Overleaf bottom: Soil colors collected throughout the western US, collected by Karen Vaughan. Photo courtesy of Karen Vaughan

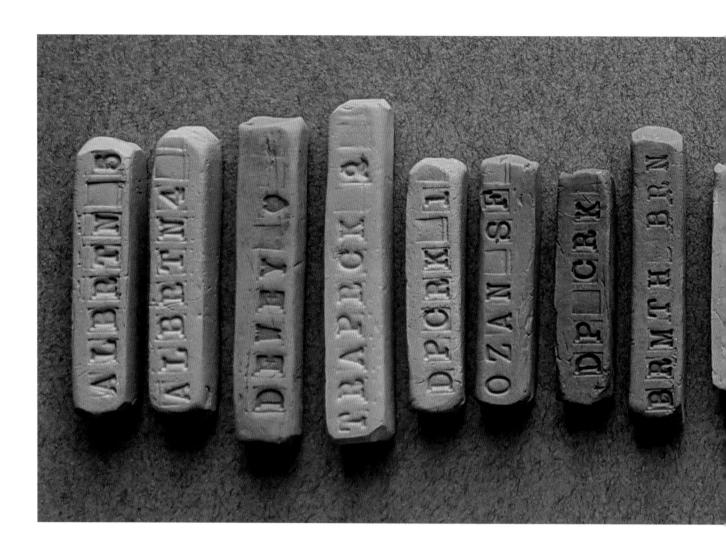

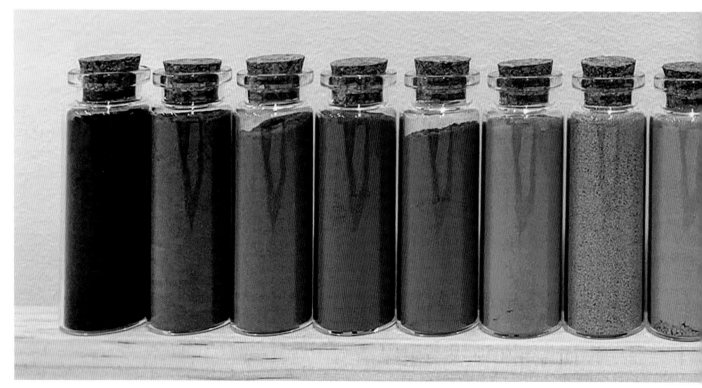

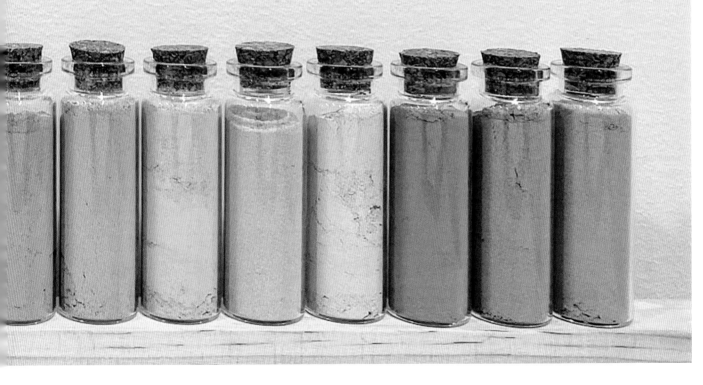

Collection of raw clay pastel colors. Photo courtesy of K. Jodi Gear

all found in weathered rocks and clay deposits. Plus, with the availability of local kaolin clays, which make for excellent binders, Jodi has everything she needs right at her feet. Fine, particle-sized clays, even bentonite, are sticky and plastic when wet and often require only a few additives like gum arabic or tragacanth to bind the materials together. Calcium carbonate can also be used in conjunction with local clays to produce hard chalks. The processes for making pastels and Conté sticks are simple and can be done in the kitchen since most of the materials used are non-toxic. Oils, like linseed, can also be added to give a creamier texture, making for genuine oil pastels. The internet is filled with recipes and directional videos showing how to incorporate various materials into making pastels. A Conté stick is an easy way to integrate wild clays into a classroom setting without the need to turn clay into ceramic.

Another artist and educator using clays and sourced pigments is soil scientist and educator Karen Vaughan. Based in Wyoming, Karen explores using clays to make "soil paints" as a way to talk about soil ecology. Using art to illustrate science education isn't anything new, but with the emergence of STEAM (Science, Technology, Engineering, Arts, and Mathematics) in education and a stronger push to incorporate the arts as a way to connect people and students with the sciences, more people like Karen Vaughan are looking to clay as a narrative driver. In addition to teaching, Karen makes soil-based ecologically considerate watercolors from found pigments. Her website, www.fortheloveofsoil. org, has step-by-step instructions for making soil-based pigments that are both beautiful and help promote soil education and community activism.

Installation in wild clay

Currently, there are practicing artists exploring the use of raw, local clays to create narratives about a place and the landscape. In Margaret Boozer's piece: *Tiber Creek and Other Lost Things* (2014), she seeks to connect the viewer to parts of the urban landscape that can no longer be seen due to city development's effects (see below).

She writes: "This piece is installed in a lobby at 2nd and M, NE in Washington, DC. Tiber Creek (no longer in existence in DC) used to run under that site. I used demolition detritus (bent rebar, broken bricks), red clay from the site, fragments from the new construction (gravel with spray paint) and an 1861 map of DC in the making and underpinnings of this piece. It became about things that are connected to the site, but are no longer visible."

In this way, raw materials can speak about spaces in ways that pottery is unlikely to and help people connect to

"Tiber Creek and Other Lost Things", 2014, raw clays, brick rubble, rebar, gravel, orange spray paint, steel, 96 inches (244 cm) x 72 inches (183 cm) x 4 inches (10 cm). Photo courtesy of Margaret Boozer

the landscape through a sense of scale. These types of work can be more thought-provoking than a cup or bowl, utilizing raw clay as a way to create discourse regarding environmental conservation and land use. More and more educators are using clay in this way as a vector for teaching science, geography, and a sense of place through a material that individuals can touch and relate to in a very personal way. In the past, I have sourced clays from people's properties, only to return with a tangible object like a mug that then illustrates the inherent value of the clay on the property. In many cases, these ranchers and farmers already have a strong connection to the lands they work daily, but recontextualizing these spaces through a physical ceramic object only cements these connections further. In that way, I strongly feel that using wild clay as an educational tool in schools and community outreach is just as vital as a potter sourcing local clays for personal use.

Another way that Margaret collaborates with local educators, scholars, and scientists is through the collaborative group, Urban Soils Institute. She writes: "I'm just beginning a private commission in Troy, NY. Research on finding local clay is bringing together a fascinating group of people, including my NYC Urban Soils Institute colleagues, a broadcast journalist, the town historian, scientists at USDA-Natural Resources Conservation Service and Rensselaer County Soil and Water Conservation District, a local brickmaking scholar, elementary school teachers, and area clay artists who are eager to learn more about the science and history of the material that is the foundation of their craft, right under their feet."

In my own research into the materiality of clay, I've explored the very quality that makes clay, clay; namely plasticity. The quality of plasticity, the ability to bind together and yet still be able to be reshaped and reconnected, makes clay a unique material and necessary to the advancement of our species. Yet it is inescapable that as clay dries, and with the absence of water, it becomes brittle and fragile. I explored these traits in my MFA thesis show by hanging 250 lb (113 kg) blocks of local raw clays from a gallery ceiling (see opposite). Using the plasticity of the wet clay, I compressed the material around steel frames, which were then suspended from the concrete above. While wet, the plastic clays held together firmly, but over time, as they dried and shrank around the steel frames, the clay blocks cracked and eventually broke apart. The intent was to illustrate the duality of clay: strong when it is wet and plastic; weak and brittle as it dries and is stripped of the very water that gives it its power. These representations of raw clay can be heady and conceptual but are great examples of pushing the field of clay and ceramic arts, and promoting further research into material literacy; and of understanding a given medium and how its inherent qualities can be capitalized upon through art installation. Knowing your materials and letting the qualities of the clays you work with inform your practice is a big part of using wild clays. Every clay is different, and locally sourced materials will have their own character. Remember to embrace these characteristics and let the unique qualities of your clay inform the work you make. These collaborative connections between artist and material can have a profound impact on any person's work.

Matt Levy: Installation, MT. "Strong As Water" 2019. The slabs of clay were formed wet and cracked as they dried. This installation sought to show the duality of clay, wet and dry, and its relationship to water. Photo courtesy of Matt Levy

ARTIST SPOTLIGHTS

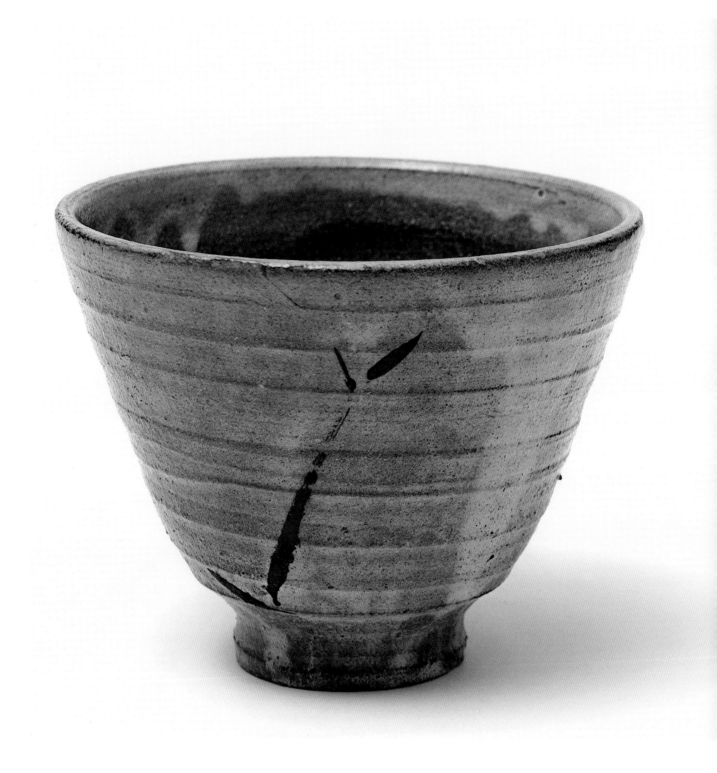

ANNE METTE HJORTSHØJ

RØNNE, DENMARK

Literally, I walk on pure clay every morning as I take my dog to the beach, a few minutes from my home. It is a type of clay that, when fired, is extremely suitable for very durable floor tiles. Only a few kilometers east of my pottery, I reach the old kaolin pit, the only one in Denmark. This unrefined kaolin was once turned into high fired bricks and, like the tiles, exported throughout the world. From there, after just another short ride, I meet the coast. Going south, with every step that I take a new clay formation is revealed, each with its own character and cultural history of what it was sourced and used for. One can find felspar, quartz sand, granite, limestone etc. It has always seemed very obvious for me to try to use what is at hand and to import as few materials as possible, to try to leave the smallest footprint possible.

After many years, I have realized that what started out as a journey dictated by common sense has turned into a true and humble love of and respect for the soil that I put my hands into and to the potters who were here before me. I feel part of the island's pottery history when struggling with this exact same material. When I read and understand technical information from a 100-year-old log book about a certain clay formation and can honestly say that this information was very useful, then I carry a small hope that it is a way of keeping this skill and craftmanship alive. There is a way to go still, before all the imported plastic bagged clay has left my studio, but I will get there eventually.

Footed cup: Clay from the old tile factory mixed with local kaolin.
Slip: local kaolin. Glaze: local felspar and wood ash. Pigment for
decoration: iron-rich sandstone from the local beach.
Photo courtesy of Anne Mette Hjortshoj

Instagram: @a.hortshoj

Previous page: Solace Kame, wood-fired stoneware, 2020.
Photo courtesy of Nancy Fuller

BANDANA POTTERY
NAOMI DALGLISH & MICHAEL HUNT
NORTH CAROLINA, US

As two potters making our work together, we have always felt that the other collaborators in our process are the clay and the kiln. Each of these elements has an undeniably strong influence on the final pots. The unique qualities of any clay are as important to a pot as different heirloom grains are for a loaf of bread, making clay itself one of the biggest aesthetic choices we make as potters.

We first began using wild local clays as a way to emulate the kind of unrefined and lush beauty of historical folk pots we admire. We have found these clays to be amazing teachers in the studio, urging us to explore their particular natures and innovate within their limitations. One clay might be too coarse and short to throw a tall thin pitcher, but it may have the most beautiful and varied texture when carved. Another clay may be so fine that it records the smallest gesture. Rather than feeling constrained, these limitations give us a framework within which to play and discover.

Our main clay body is a mixture of two dark, coarse local clays and feels like an old friend. Reveling in the texture of cut clay spurred us to start carving entire forms out of a solid piece of clay. We love the way the dark color and landscape of irregular sand and rocks richly layers under lighter slips and glazes. We are energized by this interaction, and the challenges and liveliness of this wild clay lead our creative practice.

Kaolin-slipped bowls over iron-rich clay.
Photo courtesy of Naomi Dalglish and Michael Hunt
Overleaf: Cups with freshly trimmed feet.
Photo courtesy of Naomi Dalglish and Michael Hunt

Website: bandanapottery.com
Instagram: @bandanapottery
Facebook: Bandana Pottery

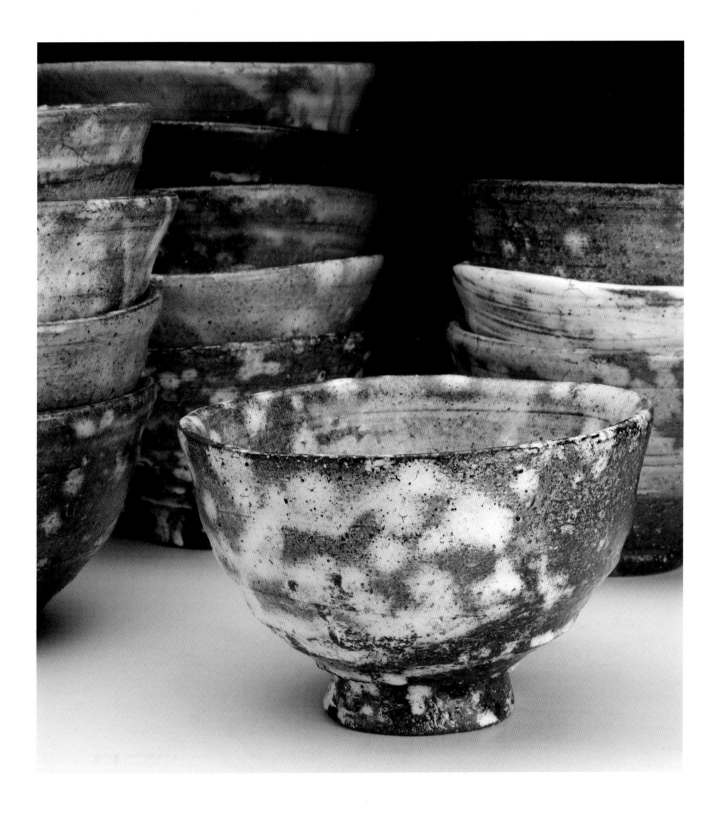

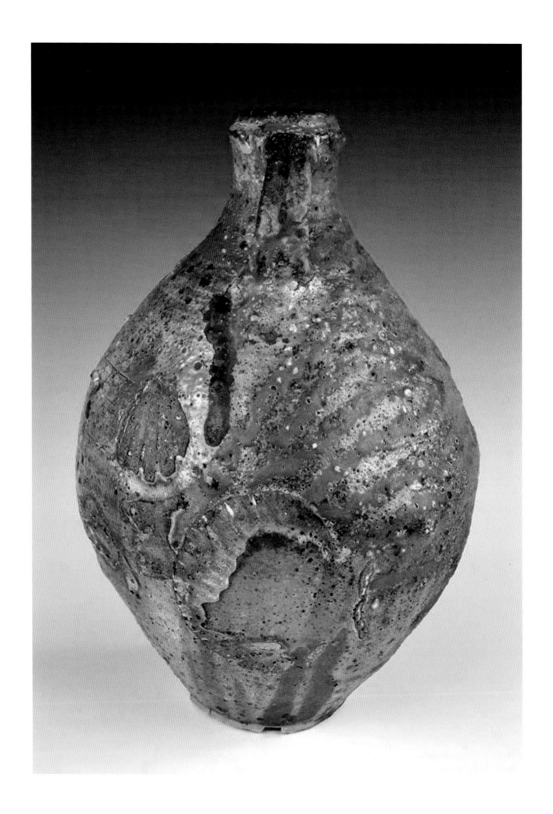

THE BARN POTTERY • NIC COLLINS

MORETONHAMPSTEAD, DARTMOOR, DEVON, UK

I've been a potter for over 30 years now, making a living and supporting my family on nothing but the sales of my pots; it's no surprise that after all this time I still feel a sense of delight and excitement when I find a new seam of clay in the bank of a river. Taking a handful of clay and feeling it for its plasticity, images emerge in my mind of the pot to be made and the wonderful colors it will produce in my wood-firing kiln. My experience with dug clays began as a student at the ceramics course I attended at Derby College of Art in the 1980s. One of the projects we were given was to dig clay from the banks of a small stream that ran by School Kiln Yard. The assignment was to make pots from this clay, use the same clay in a glaze and also to build a kiln from it. There were, of course, many failures and some successes.

Most importantly the seed had been sown to open up a Pandora's box for the years ahead. Living here on Dartmoor in Devon I am lucky to have access to a vast wealth of different clays, ranging from red earthenware clays, high-firing ball clays, and of course china clay. Clays have been quarried in this area for hundreds of years and this still is an important industry for the area, employing many people. The clays are shipped all over the world and are used in the ceramic industry, chemical industries, in paint, and of course in medicine. Even on my daily dog walk I pass an exposed seam of kaolin which I have often gathered to use as a slip on my work. I am always on the search for that heavenly natural clay that will fulfil my dreams as a wood-firing potter.

Bottle, 12 inches (30.5 cm) high, wood fired, as-dug Devon ball clay. Photo courtesy of Nic Collins

Website: nic-collins.co.uk

BEN OWEN III

NORTH CAROLINA, US

Since the late 1700s clay has played an integral role in the Owen family story. With a rich cache of good clay deposits in North Carolina, the Owen ancestors could find earthenware clay on the Seagrove surface and plasticized stoneware clay along the creek banks and in sub-surface deposits. These two diverse clay bodies found a wide range of uses in early America, long before the Industrial Revolution would offer new options in containment. While the earthenware clay was suitable for such items as dry storage and candlesticks, the stoneware clay offered a water-tight finish with greater resilience and durability for producing high-temperature wares for storage and service in homes.

By-products from the formation of Seagrove area clays, including flint rock and hematite, among other minerals, give the surface of pots a unique aesthetic with long exposure to a wood-firing and/ or salt-glazing process. Some of the regional clays contain natural mica, producing blushes of peach and apricot colors when exposed to the raw flame.

For several generations, Seagrove area potters have used stoneware clay from the Auman Clay Pond, often referred to as "Michfield Clay," just above Seagrove. This unique clay body produces a wide range of colors on the surface of the finished wares, facilitated by the unique blend of materials naturally deposited in the wild clay. Perhaps the most distinguishable difference is the unusually high percentage of sodium existing in Michfield Clay when compared to other wild clays found in the area. Some of the most successful salt-glazed finishes have been produced with this clay. In 2009, I was able to purchase the property, bringing it back into the family with the intent of preserving and securing a continued supply of the clay for future generations.

Wood-fired bottle made with local Seagrove clay.
Photo courtesy of Ben Owen III

Website: benowenpottery.com
Instagram: @benowenpottery

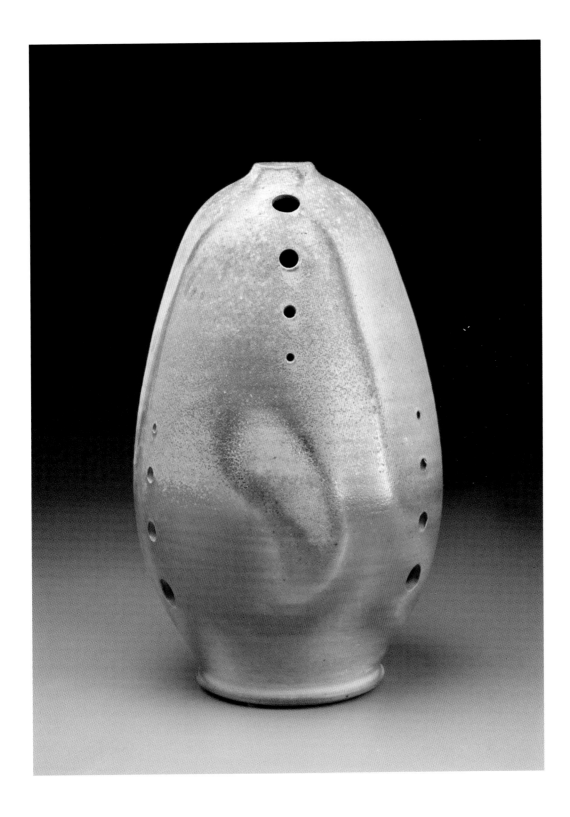

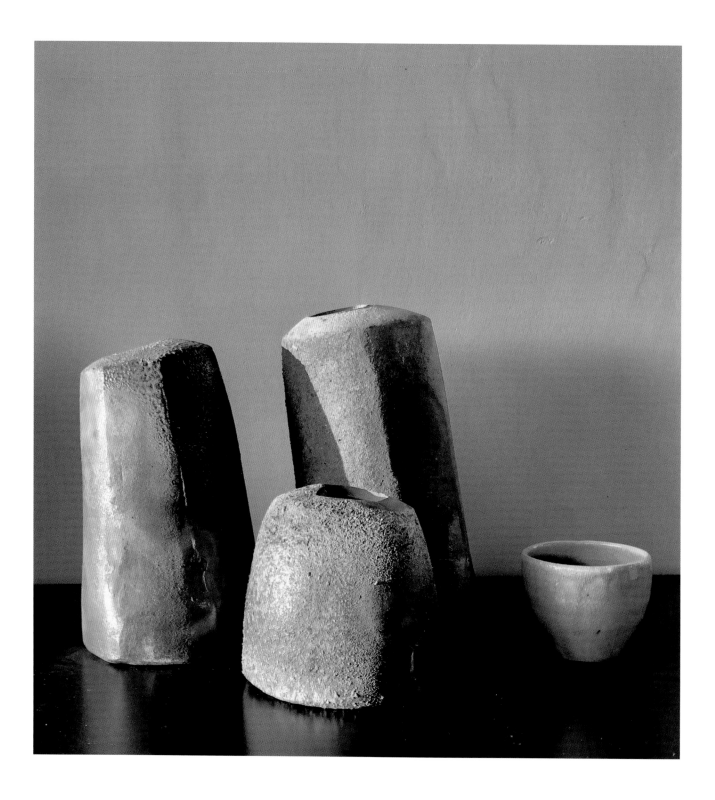

RIDGELINE POTTERY • BEN RICHARDSON

TASMANIA, AUSTRALIA

I come from settler and convict immigrants to this land, Tasmania, the island state of Australia in the Southern Ocean. Those settlers came after the first wave of the industrial revolution in Europe and set the scene for their ceramic-making of utilitarian wares and building materials for the colonial settlements.

The early use of wild clays here was framed by these beginnings and it is useful to reflect on the industrial supply system that has grown from that. I now see my material choices as positioned in a dialogue between the industrial and the wild – between an engagement with place and the feelings that engenders when gathering wild clays, and the placeless nature of commercial materials and the visual noise of more human-structured urban environments.

My making moves along a continuum between those extremes, not only with clay but also with glaze materials. When moving through nature I am at my quietest and most contemplative and this is reflected in clay bodies and glazes that maximize the use of wild materials. Conversely when industrial materials predominate there is not the same depth and connection to place that I value. Mostly the clay bodies I use are a mixture of wild clays and industrially processed materials – a mongrel mix that reflects my making journey.

The main wild clay I use is from Pipeclay Lagoon, which I view from the house and workshop every day. A weathered bowl of extremely fine plastic clay cups the tidal lagoon while linear grids of oyster beds imprint as wind and light reflect the moods of the day. This is but one of the wild clays that I use, but to wander there, to gather, process, and make with it as I learn from it has been a strong focus for my journey in place.

Grouping of wood-fired vessels.
Photo courtesy of Ben Richardson

Website: ridgelinepottery.com.au
Instagram: @ridgelinepottery

BULLDOG POTTERY
BRUCE GHOLSON & SAMANTHA HENNEKE
NORTH CAROLINA, US

As potters in Seagrove, NC, we are exposed to a rich history of working with local raw materials to make pottery. Potters without access to wood kilns or who prefer glazing on white wares, and porcelains, as well as stonewares fired in electric and gas kilns, can also distinguish and enhance their ceramic work with personally harvested raw materials. At Bulldog Pottery we have focused our energies on developing slips and glazes made from wild raw materials, developing lavish textures and surfaces that are readily incorporated into our existing studio practice.

Processing our own raw materials has allowed us to explore the possibilities of using larger and more varied particle sizes, achieving variation and new texture possibilities for the pottery surfaces. We also explore the potential of substituting local and regional raw clays into clay-rich glazes such as ash and fake ash recipes, shinos, and slip clay glaze formulations. We look for regional ores, gravels, spars, and granites and use them as additives to our glazes and slips, from coarse granules to fine dust. Some of our favorites are limonite, manganese schists, and dark-gray gravels. We often screen them out to a grit that falls between 10- and 40-mesh to add into coarse impasto slips, creating richly melting dark spots under a glaze.

For processing raw materials, our favorite tool is a gold classifying set of screening sieves that fit a five-gallon (20-liter) bucket. A rock and glass crusher is also a necessary tool that can be affordably purchased or made with welding skills. Using hard-won raw clays and minerals that we can find, whether in rural or urban environments, can bring about a renewed interest and excitement to the ceramic process, and enhance one's surfaces with unique effects. Grab a shovel, and happy prospecting.

Oval Vase, gas reduction, Cone 09, white stoneware, aggregate-enhanced slip using coarse feldspar, limonite, and manganese schist; slip bases are clay body with local North Carolina wild clay additions, with a thin spodumene matt glaze. Decoration using underglaze transfers with clear glaze. Photo courtesy of Bruce Gholson

Website: bulldogpottery.com
Instagram: @bulldogpottery

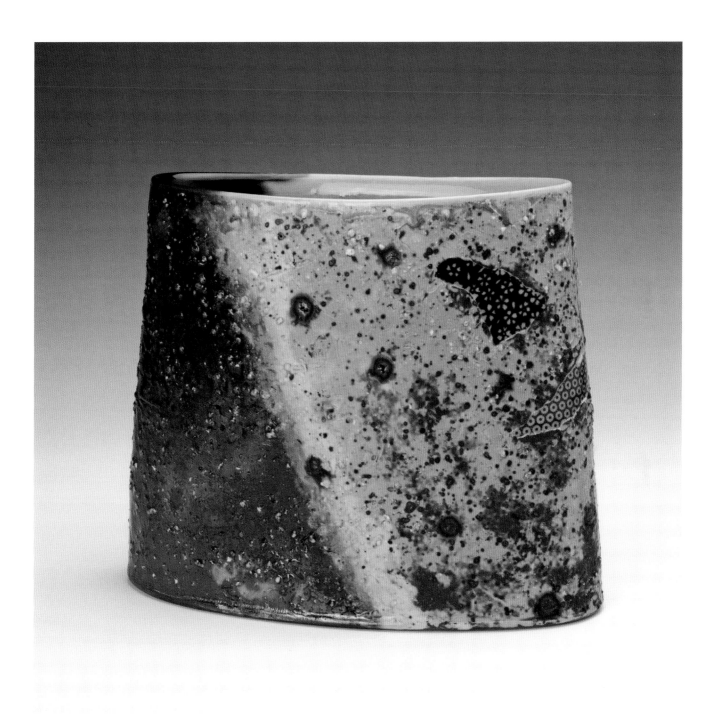

CATHERINE WHITE

VIRGINIA, US

Materials are a major element in my artistic vocabulary. Usually firing our anagama kiln twice a year, we have embraced the idea that each firing is distinct. When I'm enamored with a new wild clay, I try to find a way to incorporate it. Stancills, a sand mine in Maryland, was my first major source of different ball clays. The wide variety of iron colors – raspberry, gray, white, cream, yellow, and red – along with different quartz grits became an essential part of my repertoire. More recent experiments with STARworks Ceramics have isolated how the silica in these clays connects my firing atmosphere to the historic quality of salt-glaze firing in North Carolina.

For the most part we do not use applied glaze in our anagama wood kiln, but the cool portion of the floor that gets very little atmospheric ash is where I began to experiment with putting ash on pots. That led to pressing dry ash into wet clay during the making stage. After success there I began to explore other materials like basalt, felspar grit, white clays, and wild clays. I use these materials as if making drawings or prints on the surface of the primary clay body. I like finding and using a material on the verge of its melting point; akin to glaze but not an actual applied glaze. Because I love the nature of the raw color, I also began to play with ways of using these clays in their raw state. I use bisque sheets of clay to make prints and paintings using the raw clay, often referencing horizon lines and fields of grass as motifs. I have always admired the found object as an artistic element. Collecting wild materials for exploration feels like a similar and exciting artistic endeavor.

Tilled fields, stoneware, white slip, and red Stancills dust print, wood fired, natural ash glaze. 1 inch (3 cm) x 9 inches (23 cm). Photo courtesy of Catherine White

Overleaf: Muscle Caterpillar, stoneware, exterior impressed with NC Mitchfield clay/sand, wood fired, natural ash glaze. 9 inches (23 cm) x 18 inches (46 cm) x 9 inches (23 cm). Photo courtesy of Catherine White

Instagram: @artistpotter

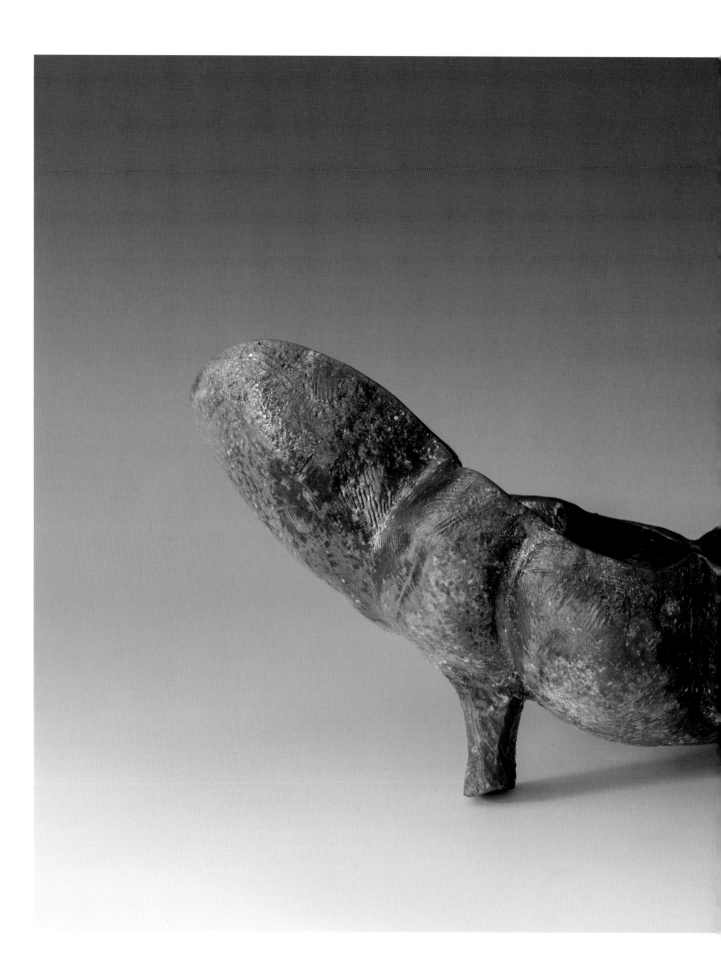

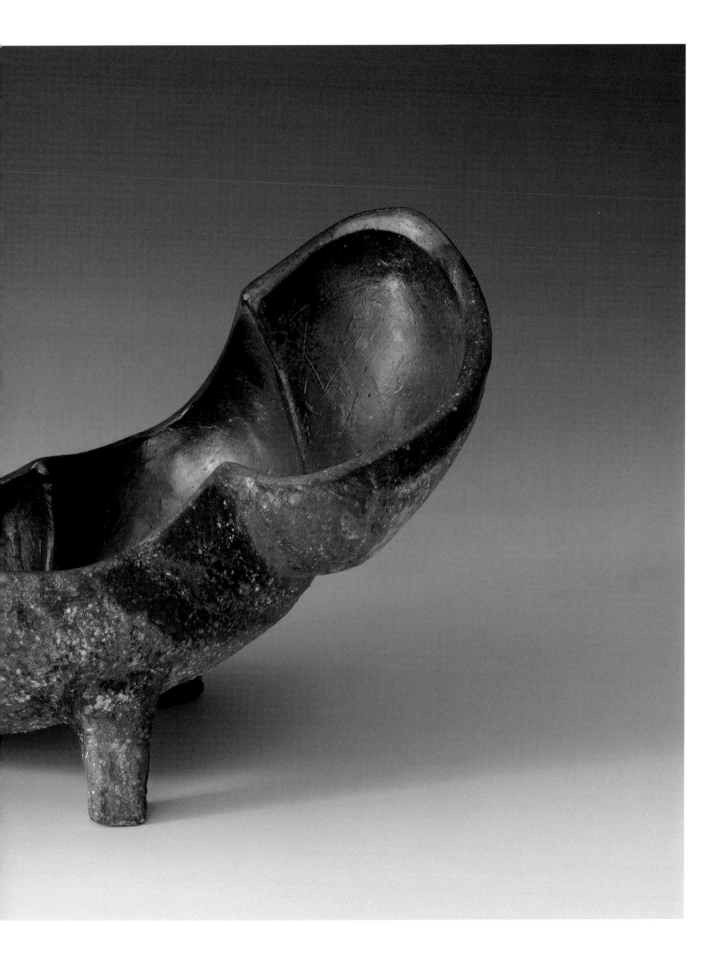

DAVID STUEMPFLE

NORTH CAROLINA, US

I'm fortunate to live along the fall line in central North Carolina, an area well known for its ceramic resources. This is where the Piedmont drops to the coastal plain and the natural resources have been used for thousands of years. Many of the deposits are small, and so have been spared large-scale industrial mining, and new clays are still being discovered.

I try to meet my materials halfway, letting them express their natural beauty while cajoling them to fit my needs. Sometimes this involves using clay straight from the ground, other times blending materials to test new ideas.

Using raw local clay is a way for me to connect with my environment and respond to its history and culture while engaging with my material in a very physical and personal way.

Wood-fired vessel made with local Seagrove clay. Unglazed with natural fly ash. Photo courtesy of David Stuempfle

Website: Stuempflepottery.com
Instagram: @davidstuempflepottery

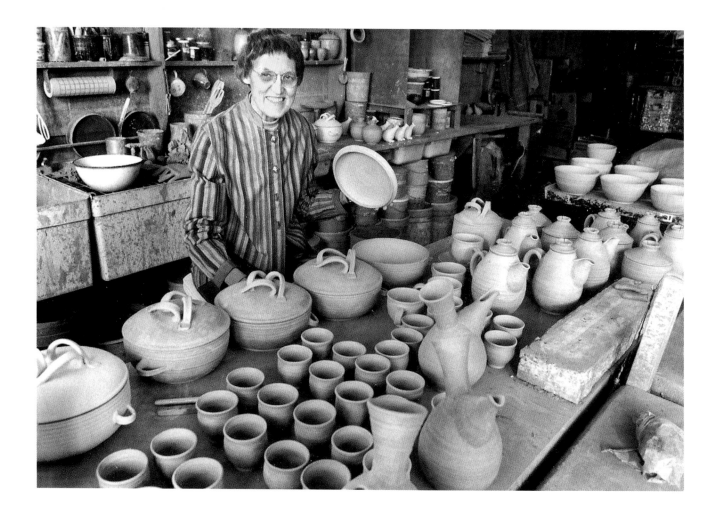

FRANCES SENSKA

MONTANA, US

Born in 1914 in Cameroon (Kameroun), Africa, to missionary parents, Frances Senska has been called the "Grandmother of Ceramics in Montana," having helped found the art department, and later the ceramics program at Montana State College (MSC) in 1946. As a professor, she was tasked with creating a new ceramics classroom for the college, which she built entirely from scratch. This self-reliance extended to her students through her teachings. She taught all aspects of ceramics from clay to fire including the digging and processing of local clays, making ceramic wares, and using locally sourced glaze materials for the final firing processes. Senska's students at MSC included internationally recognized artists like Rudy Autio and Peter Voulkos. Senska's influence is clearly apparent in Voulkos's mastery of monumental wheel-thrown stoneware functional forms with surface decoration.

Personally, Senska disdained being celebrated for her achievements and her place in American ceramic history, and when asked for an artist statement, she stated simply, "I make pots." Senska's numerous awards include honorary memberships for NCECA and the American Craft Council, as well as a Montana State Governor's Award for the Arts. She influenced the development of the Archie Bray Foundation from its infancy and was a founding member of the Montana Institute for the Arts. Her use of locally sourced clays as well as her belief that everything you need can be made yourself has had lasting impact on other artists' material research at the college, which now exists as Montana State University.

Frances in her home studio getting ready to glaze stoneware pots.
Photo courtesy of the estate of Frances Senska

FRED JOHNSTON
NORTH CAROLINA, US

In Seagrove, NC, I live on the fall line at the edge of a once ancient sea. Volcanic ash fell into that sea and over millions of years transformed into clay. It bends the imagination to understand the time involved in transforming volcanic ash into clay. I stand in awe.

Working with wild clay deepens my relationship with nature. To dig into a clay deposit is to travel back into geological time and stand in the present. I acknowledge the human achievements made with clay over thousands of years.

As a ceramic major at Alfred University, I took courses in raw materials and glaze calculation. I am forever grateful to my teacher, Val Cushing, who taught me an enormous amount about clay. She gave me the confidence to explore and use this remarkable material to make a living through experience and meeting and befriending other clay aficionados, notably ceramic engineer Steve Blankenbeker of Taylor Clays, whose knowledge is regionally specific. The journey is fascinating.

I am fortunate to have two clays on the land where I live in Whynot, NC. There is a strong spring nearby where I have found pot sherds.

Bumpy wild clay pot with ash glaze, wood fired.
Photo courtesy of Fred Johnston

Website: johnstonandgentithes.com
Instagram: @johnstongentithesstudios

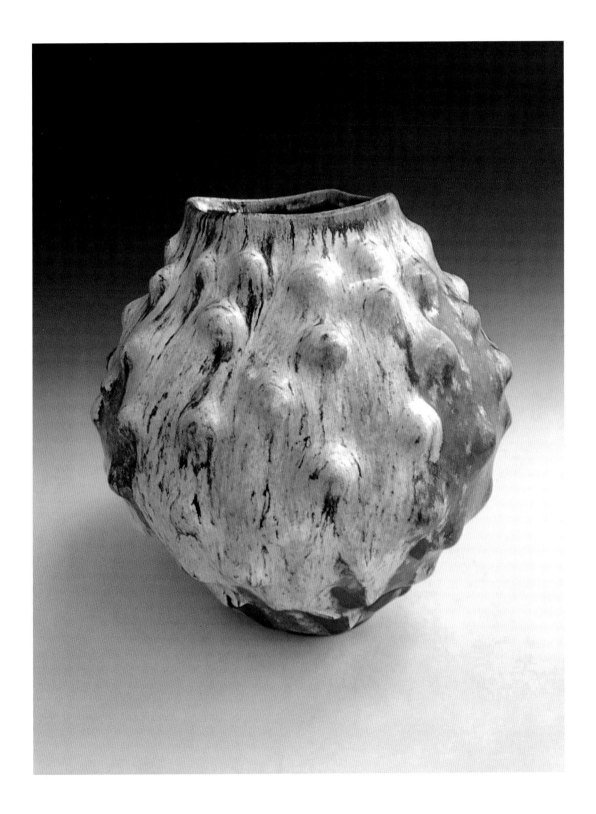

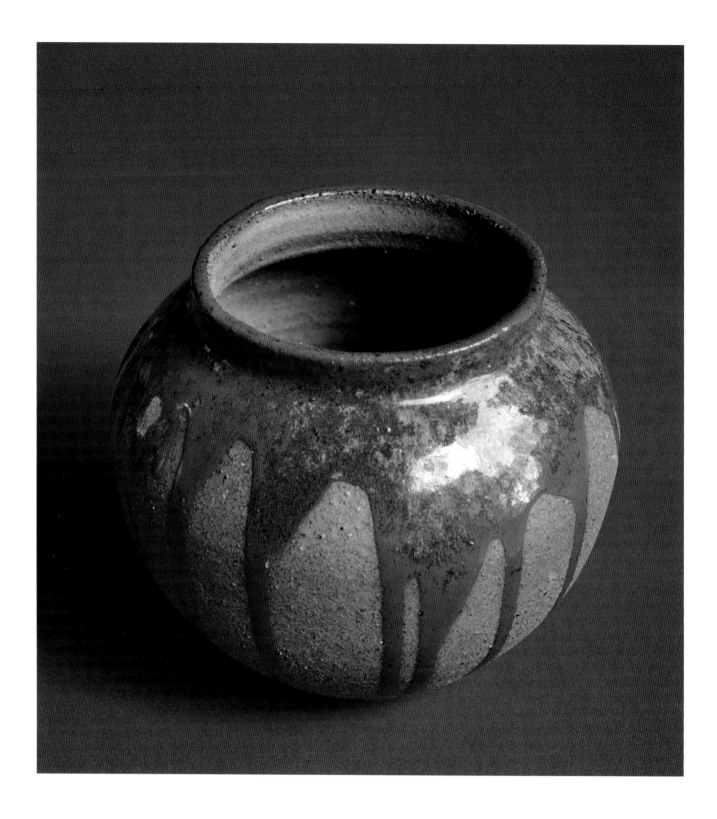

GILBERTO NARCISO

CURITIBA, BRAZIL

I produce clay and glazes by hand. I have been influenced by many authors, most notably Bernard Leach and J.F. Chiti. I pursue the widest range of ceramic practices within my reach: materials research, clay production, glazes, small kiln construction, throwing, hand-building, sculpture, and classes. I live and have my studio in the rural area of the Metropolitan Region of Curitiba, State of Paraná, southern Brazil. It is a plateau close to the coast, with an average altitude of 2625 ft (800 m). This difference is caused by the natural granite barrier, the Serra do Mar, which reaches up to 6234 ft (1900 m) in altitude. The granite is composed of quartz, feldspar, and mica, whose decomposition has spread around the best raw materials for ceramic use: clays, kaolins, silica, and feldspars.

The variety of clay colorations available is enormous. They are mainly ferruginous: yellow, lilac, salmon,

variations of red, etc. Paraná State is rich in many other raw materials: malachite, magnetite, phyllites, ilmenite, pegmatites, basalt, fluorite, syenite, barite, talc, sericite, etc. Since I became aware of the excellence of these materials I decided to use them to obtain unique results, abandoning completely the purchase of industrialized glazes. The glaze colors of Oxblood, Celadon and Tenmoku are obtained with magnetite (Fe) and malachite (Cu). I have been researching in this area for many years. I use electric and gas, as well as wood-fired kilns. The working temperature varies from 1832°F (1000°C) to 2372°F (1300°C). When one has a notion of the chemical composition of minerals and what their constituent chemical elements are used for, a universe opens up that can be generalized to all found stones and clays. I even achieved a result not found in literature, which I called "pellets." This great variety of raw materials is a rich and inexhaustible source of research and results.

Stoneware jar made with local clays from Brazil. Oxblood glaze made using magnetite and malachite as coloring agents. Photo courtesy of Gilberto Narciso

Overleaf: Stoneware jar made with local clays from Brazil. Celadon glaze made using magnetite as a coloring agent. Photo courtesy of Gilberto Narciso

E-mail: gpnarciso@hotmail.com/gpnarciso@gmail.com
Blog: gilbertonarciso.blogspot.com

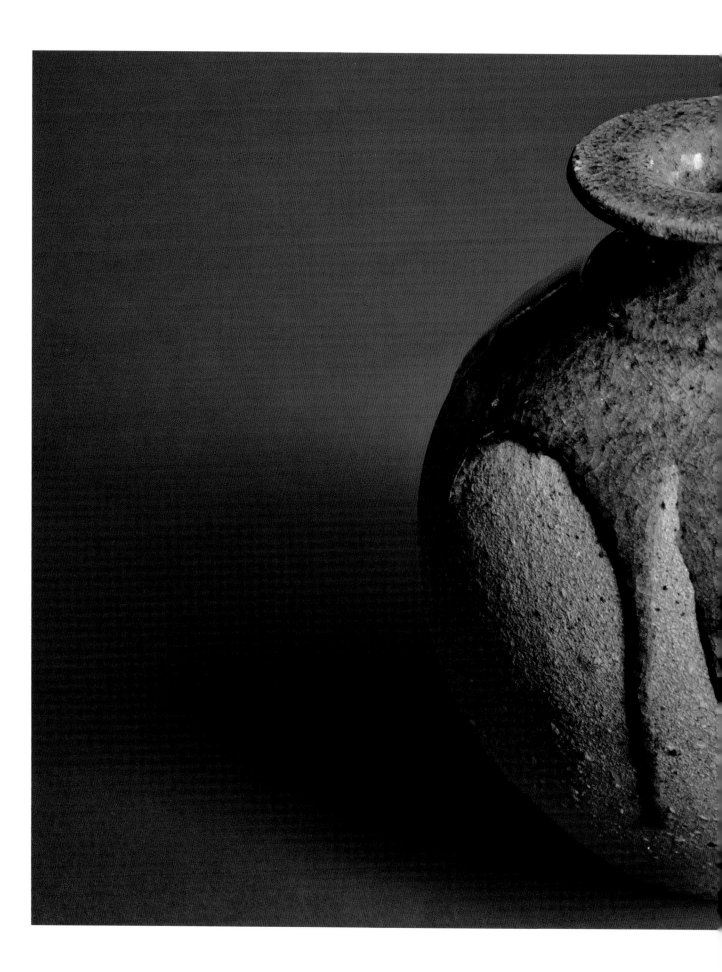

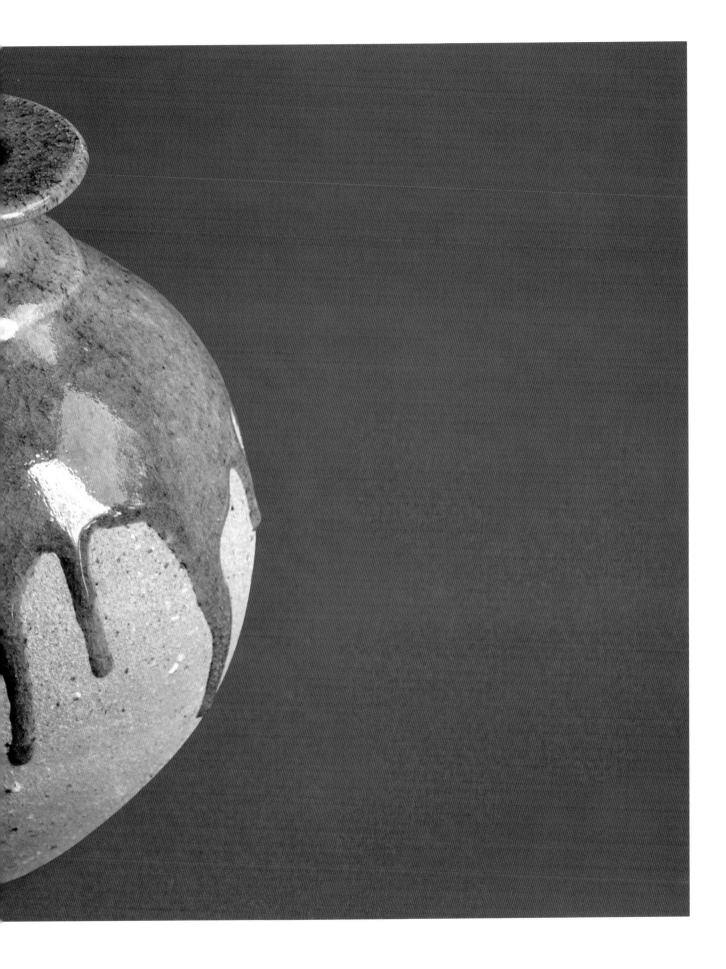

HIDEO MABUCHI

CALIFORNIA, US

Clays are weathered minerals of the earth's crust. They relate to landscape, to place. When we form and fire wild clays, we produce a type of anthropogenic pyrometamorphosed rock. We play the small demiurge. Wild clay provides a natural site of encounter for geology, materials science, naturism, and plastic art. How could we not (re)turn to wild clay, as ceramists of the incipient Anthropocene?

To work with wild clay is ancient yet prescient. It is ever more urgent for us to learn to live on earth, as we once did, as its stewards and partners and dependants. A key part of this is remembering how earth feels and looks; what its affordances are, and how we can help to frame its organic beauty. At the same time, we can marvel at the material complexity of wild clay – its non-Newtonian flow, its refractory strength, its microporosity, its nanocrystalline assemblages – and

be reminded that awe and ingenuity are two sides of a coin. On a table, in a laboratory, in a gallery, or as site-specific installation, wild clay expresses the timeless entanglements of culture and nature, ideas and things.

The photo opposite shows an outdoor sculptural work, *Follow/A Need Like Gravity* (2018), that incorporates an amphora-like vessel made from wild clay foraged near the installation site, on the campus of the Djerassi Resident Artists Program. My piece commemorates the agency of gravity, rocks, and water in convening what has effectively become a sculpture grove as generations of residents have chosen to install artwork in a particular spot on the Djerassi campus. Gravity, rocks, and water worked over ages to form the creek; trees followed the water, and artists were drawn to the resulting shade and sanctuary. Amen.

Outdoor sculptural installation: Follow/A Need Like Gravity (2018)
Djerassi Resident Artist Program. Photo courtesy of Hideo Mabuchi

Website: profiles.stanford.edu/hideo-mabuchi
Instagram: @firemousehm

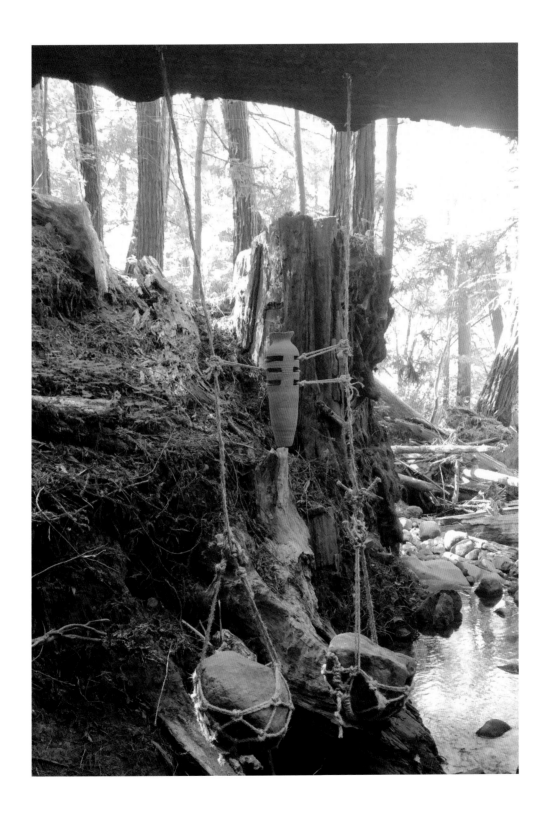

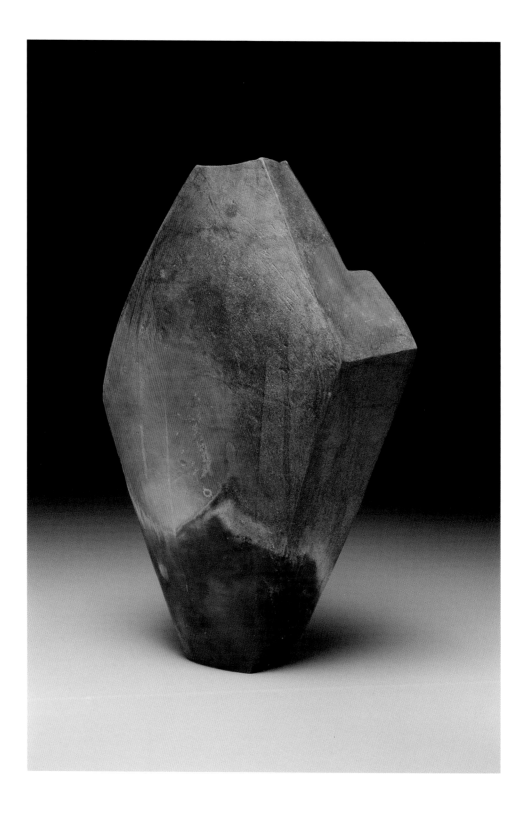

JOSH COPUS
NORTH CAROLINA, US

My work with ceramics begins with the clay. My ceramic studio practice is essentially an effort to distill the experiences of my life and infuse them into my work with clay. This practice grew out of an interest in creating personally significant work that communicates my enthusiasm for the material and the process of making, and strongly reflects the influences that inform the decisions I make in my life and in the studio.

By using wild materials dug from the river bottoms and mountainsides of North Carolina, my work gains a connection to place and establishes the materials as a valuable source of influence. Everything I make contains an element of my response to the experience of working with these materials. Every piece is infused with the qualities and character of the clays I use, and my intention is to bring out the inherent beauty of the materials in every piece.

However, my interest in using wild materials is not limited to the influence of their physical properties; it extends to the intangible qualities that these materials can bring to the work. The physical properties of my materials are not as unique as my experience of using them and it is the increased participation in the creative process that I have come to value most. Digging my own clay has increased my connection to the area where I live and furthered my relationship with the surrounding community, creating an authentic context for my work to exist in. Most importantly I find a great amount of excitement in digging my own clay, and my hope is that the enthusiasm I have for my materials is transferred to the finished product. I want each piece to carry with it the feeling I get when I'm working with wild clay straight from the ground.

Wood-fired hand-built vase with local NC clays and slips. Photo courtesy of Josh Copus

Overleaf: Wedge: handbuilt with local NC clay and slips, wood fired, 2021. Photo courtesy of Josh Copus

Website: joshcopus.com

Instagram: @joshcopuspottery

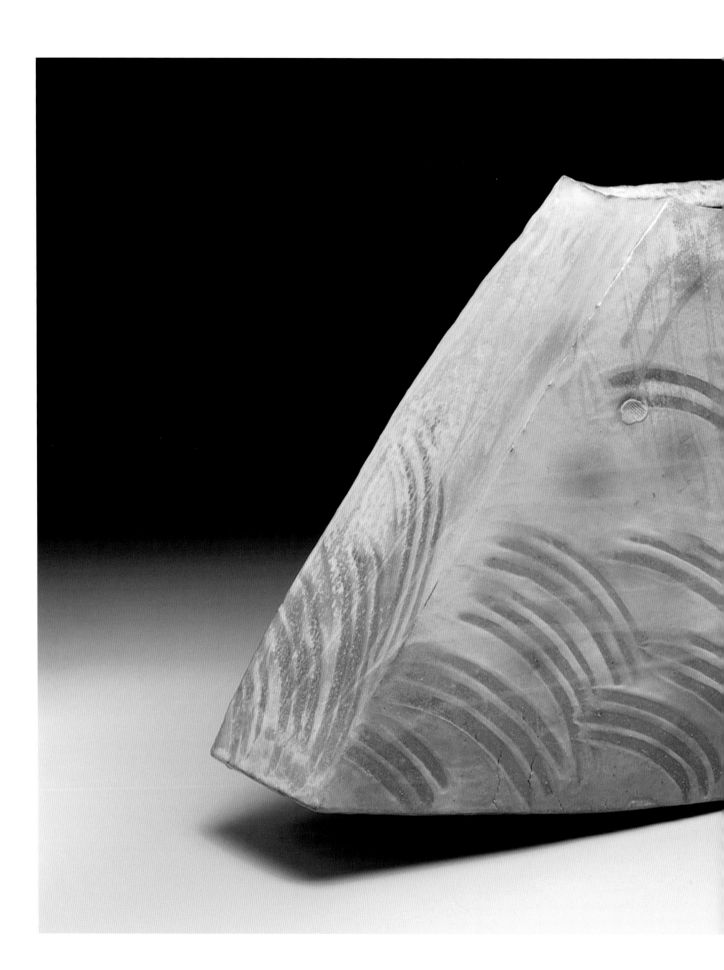

JOSH DEWEESE

MONTANA, US

My interest with using local materials grew out of a love for the quality of glaze achieved with a processed diorite granite rock found in our area. The variation and depth from using one rock as the primary component in the glaze was seductive and utterly unique, sparking my curiosity and taking me down a rabbit hole that just keeps getting deeper. Harvesting local ceramic materials as a subject of research involves many areas of study such as geology, chemistry, and the indigenous history of cultures around the world. It is the history of world ceramics.

Throughout time people have learned to use the materials available in their area to create an expression of identity. Often an aesthetic is associated with a tradition because of the geology of where it was made and the process developed to use what was available. Now we can get clay from the other side of the world because of the unique qualities it might bring to our work, which is indeed a miracle, but collectively not without cost. In this modern age of convenience, the wisdom derived from harvesting materials from the earth has been derailed and the aesthetic identity of a region is no longer relevant. There is a disconnect with this facet of consciousness. Developing a practice making use of the materials available locally can open up a new sense of understanding and lead to new directions in your work.

Wheel-thrown plates glazed with dolerite/whiting glaze and fired to Cone 07. Photo courtesy of Josh DeWeese

Website: joshdeweese.com

JUGTOWN POTTERY

NORTH CAROLINA, US

**Potters: Vernon Owens, Pamela Owens,
Travis Owens, and Bayle Owens**

As members of a family that have made pottery for generations, sourcing local clay is part of our process. The clay throughout the North Carolina Piedmont is mainly secondary clay and it has many variants due to the formation of this area. The weathering of rocks over millions of years has created a trove of diverse clay deposits. Many clay deposits, although relatively small by industrial standards, provide wonderful clay for potters. These can be interesting and challenging; a deposit may provide dependable clay, sometimes for years, before impurities begin to emerge and suddenly it will no longer work.

Jugtown Pottery; Vase by Travis Owens; Jug by Vernon Owen; Fox by Bayle Owens. All wood-fired salt glaze from the Groundhog Kiln. Photo courtesy of Nina Salsotto Cassina

Website: jugtownware.com
Instagram: @jugtownpottery
Facebook: Jugtown Pottery

Having experience handed down through the years, we have gained knowledge about things that do and don't work with the clay present in our area. One thing that is prominent from this experience: clay changes. It is of the earth and you cannot expect to get consistent results for decades. You must be willing to accept nuances and differing outcomes; this is what makes the use of native clay special and each pot wonderful.

At Jugtown, we make pots for our customers' pleasure and use. We have several clay bodies in use, each based on the clay we dig. We prepare all our clays on site, and due to our operation being small, we process clays minimally. Blending local clay with a small amount of clay from further afield, along with other non-clay elements, such as feldspar and pyrophyllite, balances the body and allows us to create durable, quality pieces.

We like the warmth we get from local clay when wood fired in a reduction atmosphere. Plasticity on the wheel, the feel of a fired piece, and the rich color of the prominent clay in a body are essential in our search for good clay. Jugtown continues to produce wood-fired salt glaze, as well as a host of other glazes and surface treatment. We also work with small batches of local clay, testing constantly to find new and wonderful combinations.

K. JODI GEAR

MONTANA, US

In my quest to create dry pastels and Conté-like drawing sticks from the pigments I've foraged, I searched online for recipes and started experimenting. I quickly discovered that the finest powder levigated from soil samples with a high clay content made an excellent binder for these pigment sticks, and there was no need to add the traditional pastel binders of gum tragacanth or methyl cellulose. Depending on the type and amount of clay in each soil, I can create pigment sticks that range from a soft pastel consistency to almost crayon-like. They are water-soluble, so they work well as a base drawing underneath a watercolor painting, or on their own like a pastel.

Foraged pigment drawing sticks made from local materials. Photograph courtesy of K. Jodi Gear.

Website: todayatmydesk.weebly.com
Instagram: @kjodigear

KAREN L. VAUGHAN

WYOMING, US

When was the last time you thought about soil? Truly spent time thinking about the importance of the life-sustaining material that we all rely on. Maybe it was while considering a personal garden or a potted plant. Or when you passed fields of crops growing or being tended in a vast field. We're going to do something a little different – toss out all your preconceived notions about soil – and start fresh. We can check a few boxes regarding the critical partner soil is in climate resilience, provisioning food, and filtering water. Thanks soil.

I now urge you to consider soils through a lens that allows you to truly notice their importance – just for being soils. Too much? Hang on with me. When you traverse a favorite ecosystem you take in the smells, the sights, the feelings you experience while in this special place. But stop for a moment and consider that none of that would be possible without what is below your

field of view – below your feet. Soils are often hidden from view – both literally and figuratively. It takes a keen eye to notice soils exposed in streambanks or eroded alluvial fans. But on an entirely different level, we take soils for granted. We are thankful for the towering trees and flowering shrubs – the charismatic megafauna who travel among us – and, thanks to soil – it's all possible.

Through sharing and creating with soil colors, I am able to expose soil's beauty in an entirely different way. By showing others that soils are alive, worthy, and stunning, we gain an appreciation for this critical natural relative that has been here for us all along. Soils, however, are struggling in places – with regard to erosion via wind and water, burial via cities, towns, and roads – health in an agricultural context. If we can see soils, we can know soils, and we can work together to conserve soils. Through soil color expression, we can do that.

A pan of dried clay with a muller print of the soft hematite also shown as a watercolor pan. Photo courtesy of Karen Vaughan

Instagram: @theartofsoil/@fortheloveofsoil
Website: www.fortheloveofsoil.org

KAZUYA FURUTANI

SHIGARAKI, JAPAN

I use several different Shigaraki local clay bodies for different purposes. Much of my Shigaraki-style pieces are unglazed anagama-fired works with red flashing and juice green drops. For this work, I choose several wild clays, including a very coarse Shigaraki wild clay, a more plastic Shigaraki ball clay, the Kinose wild clay which is a lower refractory light-yellow clay, and a lower refractory Shigaraki white clay which I occasionally add into the main clay body. I wish to use just one wild clay body but it's too coarse and not plastic enough. It could cause water leaks after firing, so I make my own clay blend to avoid those problems.

For my recent series of wild clay pieces, I have started using wild clay pastes on the surface to have interesting textures, since Shigaraki wild clays are very high refractory and hard to handle. Those clay pastes are coarse ball clays and red wild clays which I collect from my hometown. As a potter in Shigaraki, I always think of the best use of these clays because they won't go back to usable clays after they are fired, and we need to protect the environment and the ecosystem as well.

I'm very thankful that my father, Michio Furutani, left some very old Shigaraki clays for me. He told me that you had to buy good clay when it's available even if you need to borrow money. However, his clays were too valuable to use, so I dug my own clays by myself and tested them many times for years. But just recently, I began using the clays he left little by little because I've become closer to the age my father was before he passed away. I was also fortunate to help my father build kilns many times at a young age. When he was working on *Anagama: Building Kilns and Firing*, I was in a rebellious age, so I reluctantly helped with his kiln-building projects, but now I really appreciate that I was able to see his methods and make use of these experiences in building my own kilns.

I've started thinking about making pots in very different styles from Shigaraki. My dream is to make pots using local wild clays and firewoods in different communities or countries, climates, cultures, and people, and find a way that I can express myself in my pots.

[Michio Furutani (1946–2000) was the most well-known Shigaraki potter, and published *Anagama: Building Kilns and Firing* about his experiences building Shigaraki-style anagama kilns, published in 1994.]

Shigaraki Wild Clay Jar: Shigaraki clay, Shigaraki wild clay slips, unglazed, anagama-fired 14 inches (36 cm) x 15 inches (38 cm). Photo courtesy of Kazuya Furutani

Instagram: @furutani.kazuya

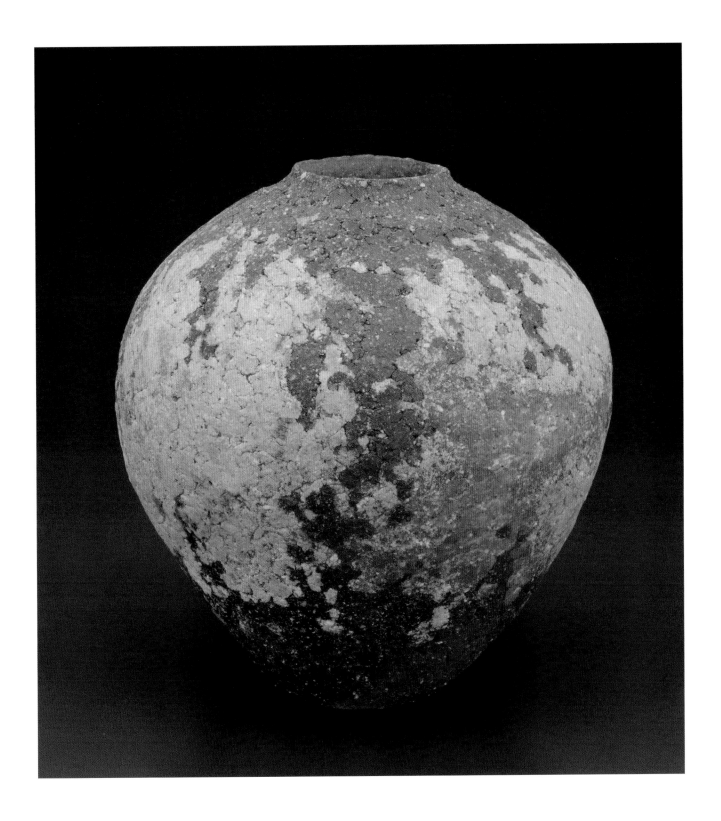

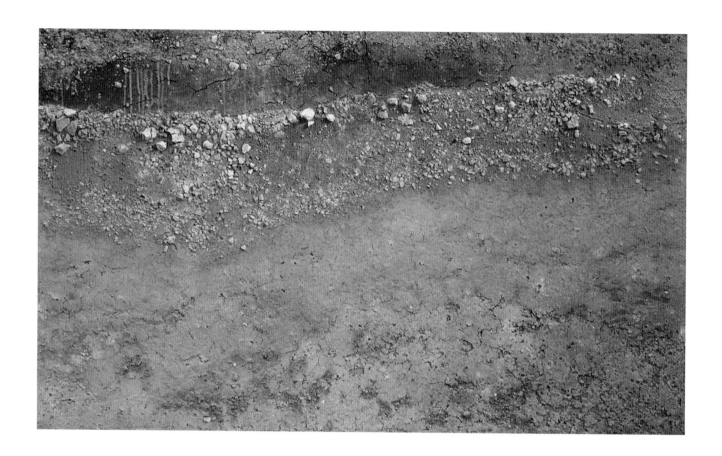

MARGARET BOOZER

MARYLAND, US

When I started grad school in Western NY, I was homesick. Seeing the black soil of the surrounding farmland, I suddenly understood my red Alabama earth as material resonant of home. Soon classmate Lisa Orr invited me along to dig Alfred's gray-green shale, and my interest in local clays had begun. Moving to Maryland, I discovered beautiful red clay at the railroad tracks by my studio, and soon rainbows of other clays nearby. Fellow ceramists Catherine White and Warren Frederick introduced me to their basalt mine in Warrenton, VA. Emlyn Stancill introduced us all to her family's clay, sand, and gravel mine, and it changed our lives.

Prospecting and foraging wild clays became part of my practice. I notice cause and effect in the environment, stealing strategies and bringing them back to the studio. I start with the material, find what it is good at, what it wants to do, and how it becomes a souvenir that carries a story.

This has led to collaborations with soil scientists and work that explores intersections of art and science. I've become friends with soil scientists at the University of Maryland and have climbed into soil-judging pits (UMD, 2019 National Champions!!). I joined the staff of NYC's Urban Soils Institute and helped found their Art Extension Service. Our purpose is to foster a collaborative space where artists make soil science more accessible and compelling, and soil scientists give art an underpinning of ecological relevance and impact.

We are propagating an ever-increasing team of artists, scientists, community gardeners, theorists, landscape architects, and activists who are equally passionate about soils and beauty. I am learning a lot about the science of my materials, and how the visual appeal of an artwork plus physical contact with material can engender personal connection and stewardship of our soils and land.

Gold Bank (Rammed Earth Series), 2012. Gold and red Maryland (Stancill) clays, steel 60 inches (152 cm) x 36 inches (91 cm) x 2 inches (5 cm). Photo courtesy of Margaret Boozer

Website: margaretboozer.com
www.urbansoils.org
Instagram: @boozerreddirt
@red_dirt_studio
@urbansoilsmania
@project_soils_usi

MARK HEWITT
NORTH CAROLINA, US

It used to be that potters moved to where there was good clay, as it was too heavy to move long distances. Distinctive regional pottery traditions developed in response to particular clays, pots were the embodiment of a place, and aesthetics were determined by the clay.

While I also use a variety of commercially available minerals, kiln shelves, a digital pyrometer, and so on, wild clay is at the heart of my practice, and I moved to the North Carolina Piedmont to be close to locally available clays. I've enjoyed the quest to find a series of local clays to blend into a clay body, as if on a pilgrimage, breaking nuggets apart to assess their cleavage, tasting small fragments, allowing the spit and slurry to run against my teeth to see how sandy or silky each clay is. I feel a deep connection to the clays that I use, so that when the clay is passing through my fingers on the wheel it is as though I am aligned with primordial geological forces.

There is a magical sticky slipperiness in wild clay that helps me make my pots; my clay body feels alive.

My practice also connects me with the continuum of the potters of this place who have urged these clays into magnificence. I honor their individual labor and brilliance. I also gratefully acknowledge the direct influence of Michael Cardew and Svend Bayer in helping me understand these things.

Using wild clay, wild glaze materials (primarily local granites), and wild wood to fire a kiln does not automatically produce good pots, but for me it is a necessary foundation, despite the laboriousness. Even the dangerous unpredictability of a wild firing seems justified when everything comes together as intended. The mysterious glow of life in the pots makes it all worthwhile.

Two vases, made with a blend of wild NC clays. Glazed with Salisbury Pink, a local granite. Wood-fired salt-glaze. 6 inches (15 cm) x 8 inches (20 cm) high; and 6 inches (15 cm) x 10 inches (25.4 cm) high. Overleaf: Slab platter, made with a blend of wild NC clays. Photos courtesy of Mark Hewitt

Website: hewittpottery.com
Instagram: @markhewittpottery
Facebook: mark.hewitt.9469

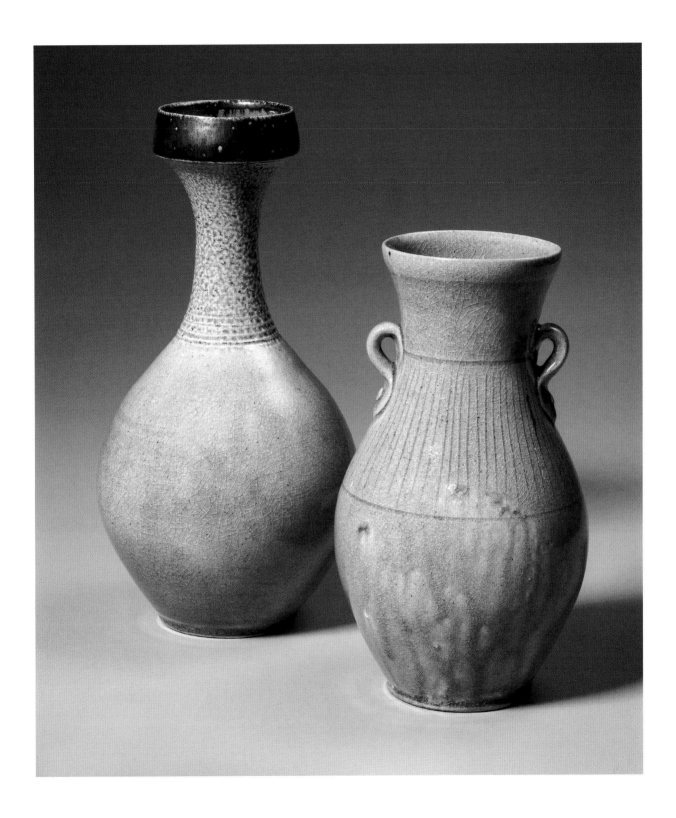

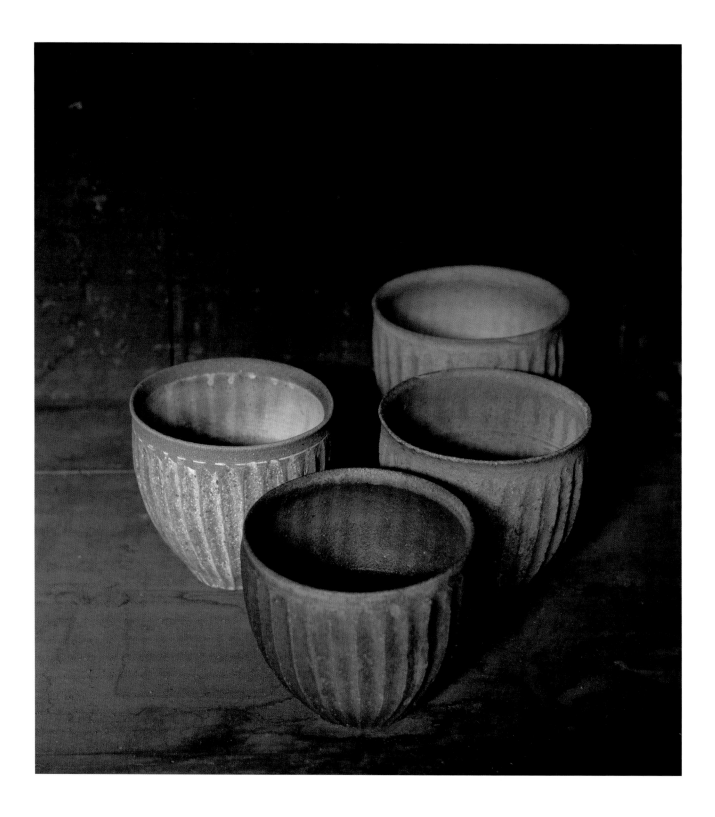

NANCY FULLER

ABERDEENSHIRE, SCOTLAND

"When I went to Shigaraki and looked at the white earth, the green forest of red pines, I suddenly imagined, completely naturally, that a forest fire here would create a large Shigaraki jar, complete with ash flow." (Shigaraki Otsubo, "Maegaki Tsubo" by Hideo Kobayashi, Tokyo Chun-ich Shimbun Shuppankyoku, 1965)

My training with Shigaraki anagama-master Shigeji Suzuki literally began on the clay hillside of his property and through him I learned that the clay is the starting point for both your pottery and kiln design. In this way, gendo or wild clay was synonymous with wood firing – they went hand in hand – which is why each region evolved its own firing style and kiln type. The clay we harvested was actually used for glaze-making but I was so enamored with it that I wanted to use it as a clay body. This love of the raw material itself was how I came to appreciate each clay's beauty. The Japanese describe this as "clay flavor" and the combination of the clay, firing atmosphere, kiln design, and firing temperature gives the pottery its own particular expression. It's precisely the wildness that contributes to the uniqueness of each pot, and as the quote above suggests, it's like forging something directly from nature, thereby giving us a tangible connection to a time and place on earth.

Whilst it has not been possible to have the same access to wild clays in Scotland, this way of thinking about clay is very much at the core of how I approach my work. I use bought unprocessed raw stoneware clays where possible and low-temperature local clay harvested from a nearby stream as a slip. Working with wild clay has been my way into wood firing and it continues to inform my practice at every level.

Fluted yunomi with assorted vitrified slips.
Photo courtesy of Nancy Fuller

Website: nancyfuller.co.uk
Instagram: @nancyfullerpottery
Facebook: @nancyfullerpottery

POTTERS CROFT • TIM & TAMMY HOLMES
TASMANIA, AUSTRALIA

The Ewenny Pottery in Wales where I grew up was founded in 1610. When I visited Ewenny on a school trip as an eight year old in the 1950s they were still making pots and processing locally dug clay. Inspired by the visit I went down to the river embankment near where we lived and dug some clay, processed it in the garden and made some pots which I fired in the coal-burning slow-combustion stove in our kitchen.

In 1974, when I was a student on the Ceramics Course at Harrow School of Art in London, Gwynn Hansen, who was working in France at the time, came to teach a short block. As a result of that meeting, she invited me to become her trainee in Australia, where she intended to set up a new pottery. Throughout the whole year of my traineeship with Gwyn in Hobart, Tasmania, I researched and tested local materials, particularly clay. The following year Les Blakeborough

engaged me as the studio technician at the Hobart School of Art to process the newly formulated clay body out of the materials we had found.

So, when it came to setting up my own wood-fired pottery, I naturally carried on using the same wild clays; I didn't know any different. I did not have the equipment that was available at the art school so I improvised. I crushed the dry clay with a sledgehammer and then my feet and slaked it down in 50-gallon (200-liter) drums using a garden rake as a blunger; then I sieved the slip through a homemade vibratory sieve and ran it out into wood-fired drying beds to stiffen up. Without a pugmill I hand-wedged and spiral-kneaded all the clay that I used in my production pottery. Michael Cardew once said that a production potter needs to wedge and knead a hundredweight of clay every morning. His words were a mantra to me and surprisingly my wrists are still fine even though I do have a de-airing pugmill now.

Wood-fired jar with natural fly ash by Tim Holmes.
Photo courtesy of Tim Holmes

Website: potterscroft.com.au
Instagram: @potterscroft

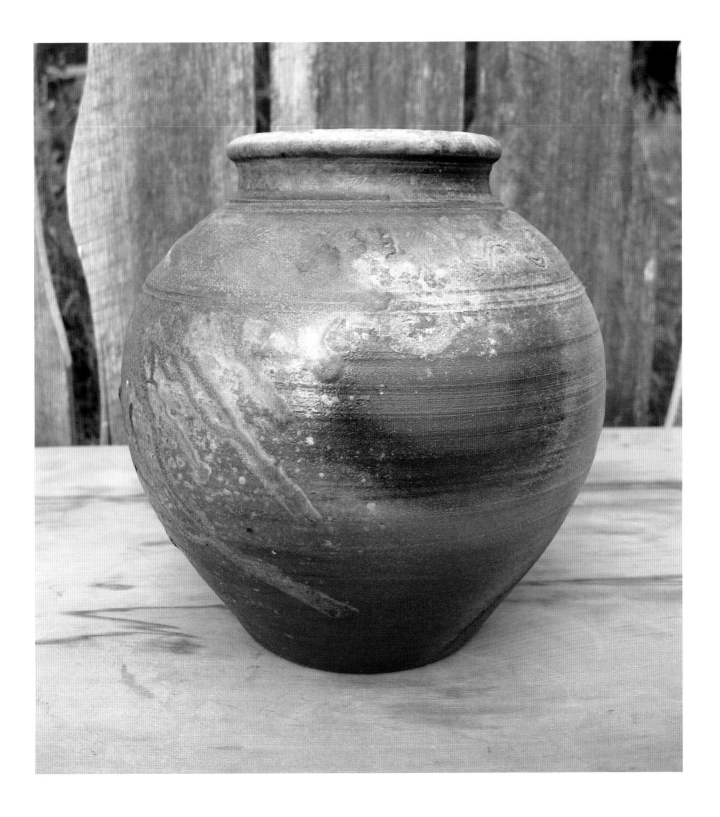

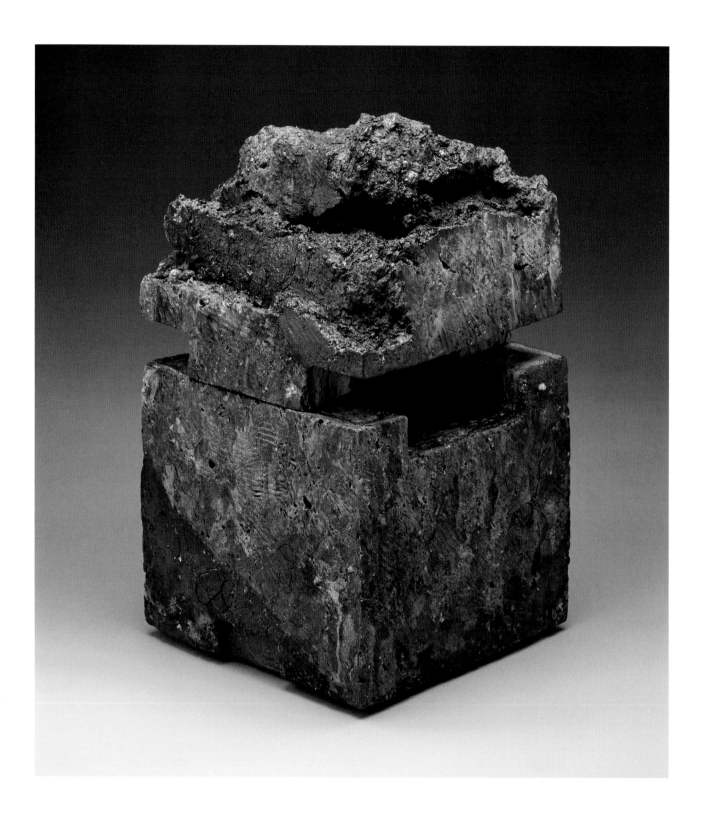

RYUICHI KAKUREZAKI

BIZEN, JAPAN

Bizen ware, an unglazed vitreous stoneware, comes from one of Japan's historical kiln sites with long traditions.

Considering both this tradition and the future, and because of the diminishing availability of the Hiyose paddy clay that has served as the primary clay for Bizen ware, I am using a technique I call Konkou, which means "mixture", but implies the intentional use of the raw clay as found with all its sand, rocks, and other impurities.

The raw clay is not levigated or refined; I simply allow the raw clay to absorb water and use this material to make slabs. This clay can't be used for coil building or throwing; it cannot even be kneaded or wedged.

Firing is done in an anagama kiln, using pine as a fuel and taking as much as two weeks to reach a temperature of 2282°F (1250°C).

By intentionally including "bad" clay, I aim for new expression as I explore the possibilities of unglazed vitreous stoneware.

This is my way of expressing my gratitude to the earth and giving something in return.

"Tou-bako, The Clay Box". Bizen clay,
anagama fired, 8 inches (19.5 cm) x
7.76 inches (19.7 cm) x 12 inches (30.5 cm), 2016.
Photo courtesy of Ryuichi Kakurezaki

SANDY LOCKWOOD

NEW SOUTH WALES, AUSTRALIA

Because I wood-fire and salt-glaze, clay forms the foundation of my practice. My process exposes the character of the clay in a very strong way. Salt glaze hides nothing so there is figuratively "nowhere to hide".

I consider the making of my work as beginning with the choice and processing of clay.

I make my own clay bodies. These are not entirely made from wild clay, but there are significant components of my bodies that include wild clay.

The kiln also has a significant say in how my finished work looks. It works with the character of the clays I use to produce the look I am seeking. The input of the kiln is unpredictable and this is amplified by the unpredictable nature of my wild clay inclusions. It is this unpredictability that I find significantly engaging. In my practice I try to let the clay speak and using wild clay has

become an important part of my aesthetic vocabulary.

My wild clay components include a couple of local clays as well as such things as tiny stones gathered from ant nests on my property. These and other such materials are included when I make my clay bodies, and also along the way as I make my works.

Using wild clay carries across a number of forms I make, and in each piece its contribution is unique. The interaction between unpredictable materials and unpredictable firing produces results that cannot be imagined beforehand. These results feed into my creative development by suggesting things to try, and provoking me to ask, "What if?"

This is why using wild clay and other wild materials has become an important part of my practice.

Wood-fired and salt-glazed porcelain.
Photo courtesy of Sandy Lockwood

Website: sandylockwood.com.au
Instagram: @slockwood737

STEVE HARRISON

NEW SOUTH WALES, AUSTRALIA

I live as locally and sustainably as possible, I grow most of our food, and use only locally collected materials.

I washed weathered basalt gravel to extract the few microns of clay-like material that might have weathered from the surface. After many washings and throwing away the gravel I was left with a tub full of what looked like cold milky tea. When left to settle, I could decant the water from the top and collect the few inches of thick sludge from the bottom. Once stiffened and left to age for a year or two in a cool dark place, this rock dust became almost throwable into simple bowl forms.

When wood fired in our kiln made with our own hand made fire bricks, made from a local bauxite. This basalt sludge with its 20% of iron oxide fired to a lovely matt black and worked well with our wood ash and porcelain stone opal glaze. I also discovered a local deposit of hard aplite stone that, when crushed and ball milled into a fine slip, then aged for a few years, could eventually be thrown and fired into a fine porcelain. I was completely astonished that this was possible. It turned out that this crushed and milled local hard stone porcelain could be developed into an almost plastic clay body with ten years of careful ageing! It took me most my life to discover this!

Tragically, my pottery, kiln shed, kiln factory, wood shed, and many tonnes of split wood were all burnt in the catastrophic bush fires here in December 2019, but my greatest loss was several tonnes of aged porcelain stone body.

Basalt blackware clay body with wood ash and porcelain stone optical "opal" glaze. Photo courtesy of Steve Harrison

Website, book sales, and blog: tonightmyfingerssmellofgarlic.com

STUDIO ALLUVIUM • MITCH IBURG & ZOË POWELL
MINNESOTA, US

We established Studio Alluvium as a space for researching Minnesota's unique clay and mineral resources and for sharing our passion for natural materials with other makers throughout the world.

Alluvium refers to deposits of sediments transported by rivers and streams. We chose this name because of how it relates to our practices as artists. Using geological maps and documents, we travel throughout the state in search of a wide range of clays, stones, and minerals which we bring to the studio to prepare and use in different applications.

Locating and gathering materials in this way is a laborious but meaningful process that enriches our lives in many ways. It allows us to directly engage with the landscapes around us and the events that shaped them, to explore options for a more sustainable practice as ceramic artists, and to pursue unique expressions unachievable by industrially refined materials. Ultimately, this work makes every detail of the finished product matter.

Although we share the same materials, our responses to their properties are often very different. By blending clays and adding or removing aggregate, we each personalize our own clay bodies to serve as the foundation for our work. These unique recipes give us room to explore a range of ideas related to our respective interests of geological history and biological development.

Finished work by Mitch Iburg and Zoë Powell on display in their gallery. Photo courtesy of Mitch Iburg and Zoë Powell

Website: mitchiburg.com
Instagram: @mitchiburgceramics
Website: zoepowellceramics.com
Instagram: @zoepowellceramics
Website: studioalluvium.com
Instagram: @studio.alluvium

UNURGENT ARGILLA • NINA SALSOTTO CASSINA

MILAN, ITALY

Unurgent Argilla is a vocabulary of materials, colors, and textures, a visual and physical study of what's around me, repeated on spherical vessels, which I use as a canvas to convey a spatial and geological narrative. Researching, digging, testing, and working wild clay at the wheel helps me connect to a place. I started to forage clay in London and recently moved to Italy, where I work mainly with wild clays found around Milan and rocks from Italian volcanic islands.

I dig small quantities of each material, process clays by hand, and use them pure when possible. My city studio doesn't allow for storing and processing of large volumes, so I haven't completely replaced commercial materials, but I try to make vessels in which the commercial clay body is just a means to showcase the wild clay. I also use rocks, mainly basalt, pumice, and rhyolite, as grog, glaze, or as a dusting on the surface to accentuate the form.

I aim at abstracting as little as possible from the original earth, maintaining what could seem an imperfection, be it soluble salts surfacing during firing, organic and mineral impurities, or non-homogeneous texture, to respect what the material really is.

I try to adapt my method at the wheel to each wild clay. Recently I've also started to work with pinched forms for those clay bodies that aren't plastic enough for the wheel. I try to blend the rigor of a scientific approach with the adaptability needed for different materials and circumstances.

Stromboli basalt on white stoneware, thrown at the wheel, fired multiple times in an oxidizing atmosphere at 1250°C (2282°F). Photo courtesy of Nina Cassina

Instagram: @unurgent.argilla
Email: unurgent.argilla@gmail.com

YOLANDA RAWLINGS

NEW MEXICO, US

Micaceous clay is a unique and naturally occurring primary clay found in Northern New Mexico. As a building material with remarkable strength and an appealing beauty, it has been used to make flameproof cookware for over seven centuries by Jicarilla Apache, some Pueblo tribes, Hispanic communities, and Anglo immigrants of the Sangre de Cristo communities of the area.

I had the great privilege of learning the tradition and craft of micaceous clay pottery-making and its place within the indigenous cosmology from my teacher, mentor, and friend, Felipe Ortega. Felipe is widely credited with reviving the craft of micaceous clay cookware in New Mexico. He taught me and I am carrying on his legacy of creating cooking vessels, and sharing the building of these vessels with all who respect the traditions of this craft.

Micaceous clay vessels are birthed from a philosophy of gratitude and prayer to Clay Mother for allowing us to dig clay from her belly. When one constructs a vessel, it is done in co-creation with Clay Mother in birthing her pottery children into existence. It is an awesome responsibility to undertake.

I create each micaceous clay vessel in traditional and authentic ways using only hand-harvested, organic, wild micaceous clay. Gratitude is given with each step of the process and all rituals and reverence to Clay Mother are righteously offered.

Through the building process of coiling, scraping, sanding, and polishing, the pots are prepared for firing. This final firing in open flames and ponderosa pine bark gives unique character to each micaceous clay vessel with its own special markings and is analogous to the individual maturation of all sentient beings.

Traditional bean pot made with micaceous clay sourced in New Mexico.
Photo courtesy of Yolanda Rawlings

Website: micaceouspotter.com
Instagram: @micaceouspottery

BIBLIOGRAPHY

Blakely, Matthew, *Rock Glazes Unearthed*, Self-published, 2021

Bloomfield, Linda, *Colour in Glazes*, A&C Black, 2012

Blumer, Thomas John, *Catawba Indian Pottery*, University of Alabama Press, 2004

Cort, Louise Alison, *Shigaraki Potters' Valley*, Kodansha International, 1979

Cushing, Val M., *Cushing's Handbook*, Alfred University, 1994

Furutani, Michio, *The Anagama Book*, Rikogakusha, 1994

Hamer, Frank and Janet, *The Potter's Dictionary of Materials and Techniques*, Sixth Edition, University of Pennsylvania Press, 2015

Harrison, Steve, *Rock Glazes, Geology and Mineral Processing for Potters*, Hot and Sticky Press, 2003

Harrison, Steve, *5 Stones: A Ceramic Journey*, Hot and Sticky Press, 2019

Holden, Andrew, *The Self-Reliant Potter*, Simon & Schuster, 1984

Hutchinson Cuff, Yvonne, *Ceramic Technology for Potters and Sculptors*, University of Pennsylvania Press, 1996

Lawrence, W.G., and West, R.R., *Ceramic Science for the Potter*, Second Edition, Gentle Breeze Publishing, 2001

Mason, Ralph, *Native Clays and Glazes for North American Potters*, Timber Press, 1981

Rhodes, Daniel, *Clay and Glazes for the Potter*, Krause Publications, 1957

Rogers, Phil, *Ash Glazes*, A&C Black, 2003

Shigaraki Ceramic Cultural Park, *Great Shigaraki Exhibition, 21st Century Lakeland Shiga Project: Celebration of Shigaraki Ceramic Cultural Parks 10th Anniversary*, 2001

Shigaraki Ceramic Cultural Park, *Miraculous Clay – Three Ceramic Landscapes Showcasing Shigaraki Ware*, 2020

Sutherland, Brian, *Glazes from Natural Sources*, A&C Black, 2005

Welch, Matthew, *Body of Clay, Soul of Fire: Richard Bresnahan and the Saint John's Pottery*, AHSP, 2001

Willers, Rhonda, *Terra Sigillata: Contemporary Techniques*, American Ceramic Society, 2019

Yoichi, Shiraki, *Industrial Ceramics*, Gihodo Publishing

GLOSSARY OF TERMS

Acid – An acid is a chemical compound which liberates protons, the positive electrical charges at the center of atoms. For the potter acid solutions are used in slips and slops, acidic compounds in bodies and glazes, and acidic gasses liberated during firing. Silica is the most prominent acid used by ceramicists.

Alumina Oxide – Second only to silica in its importance to ceramics, alumina oxide is combined with silica in the clay crystal and it is this combination that causes a flat crystal and thereby gives clay its plasticity. Alumina oxide is most often introduced into clay bodies through feldspars and kaolin clays.

Alkali – The opposite of acid. Potters call the glaze and body fluxes their alkalis. These are the non-coloring metal oxides which react with the acids in the presence of heat to produce silicates (glasses). Lithium, sodium, and potassium, metals in the first column of the periodic table, are soluble in water and used as fluxes in making vitreous clay bodies.

Ball Clay – Ball clays are usually accepted as once-removed kaolins, containing high proportions of the kaolinite mineral but also free silica and the oxides of potassium, sodium, calcium, and magnesium in the form of mica. These impurities lower the vitrification range. Considered highly plastic, ball clays are often the basis of many commercial clay bodies and can be added to raw clays to increase plasticity, or to slips and glazes to help keep materials in suspension.

Ball Mill – A grinding mill used for processing minerals and other materials. Sealed in a porcelain jar with water and grinding media made of either alumina oxide balls or other dense hard substances like agate or quartz, the mill rotates by resting on driven spindles. The speed of rotation is such that the medium falls onto the material continuously, with the water providing dispersion of the particles.

Bentonite – Plastic volcanic clay used in clay bodies as a plasticizer. Swells extensively when wet, giving it a high shrink rate, and suitable in clay bodies only in minute amounts, usually around 2% by volume.

Biotite Mica – A group name for a series of alumino-silicates related to clay, montmorillonite, and feldspar, and existing as impurities in them. Mica is present in acidic and intermediate rocks and is one of the products of their decomposition along with clay, feldspar, and quartz. The presence of some micas in clay bodies can be advantageous in that they provide slower vitrification rates in clays.

Black Core – The dark-gray center which shows in the cross-section of some fired bodies. It is caused by local reduction and occurs when the carbon inside the body has not been successfully burnt out. All clays contain some carbonaceous matter, especially minimally processed raw clays.

Bloating – The unwanted blistering of the body caused by trapped gasses. This defect occurs in mid-range clay bodies and stoneware and between body and slip in slipware. During a firing, many gasses are liberated from the clay body, most escaping through the pores in the body and if necessary through any molten glaze surface. Bloating is a big problem when using raw, wild clays. Organic materials, naturally found in sourced clays, need time to burn out during the bisque stage. If carbon is not released from the clay before vitrification starts, these gasses become trapped and can lead to other defects. See **Black Core**.

Calcine – A process by which materials are purified through the action of heat. Typically, this term is used to describe firing materials such as kaolin and ball clays but is also used when referring to firing rocks and minerals in order to weaken the physical bonds and make them easier to crush by hand. With clays, calcining to the region of 1292°F (700°C) removes chemical water and ultimately the plasticity of the material. This is often done for use in slips and glazes, where the potter wants the alumino-silicate qualities of the clay but needs to lower the plastic nature for better fit when applying such slips to bisqueware. Most potters use simple straight-walled bisque bowls that can be filled with dry powdered clays and fired alongside other work in a traditional bisque firing.

Calcium Carbonate – Carbonate of Lime. $CaCO_3$. A stable and insoluble (in water) compound of calcium which is used to introduce calcium oxide (CaO) into bodies and glazes.

Clay – Hydrated silicate of aluminum. A heavy, damp, plastic material that sets upon drying and can be changed by heat into a hard, waterproof material. There is the idealized version often referred to as kaolinite, which is characterized to be of chemical purity, and then there is the "clay" as seen by every pottery as a fundamental part of their practice. The two are different in that the potters' clay is in fact a mix of materials homogenized for function and workability and kaolinite is theoretical in its purest form.

Colloidal Clay – Often referring to clays that exhibit high plasticity due to fine particle sizes. All particles of a substance tend to have the same predominant electrical charge residing on the surface. These particles therefore repel one another if dispersed in a liquid. Ball clay and other clays of a finer particle size such as bentonites, possessing a colloidal quality, help keep other materials in suspension when used in glaze and slip recipes, especially when used in quantities of 30% or more.

Crazing – A glaze defect where the expansion and contraction rates of a ceramic and bonded glaze surface are different enough that the glaze cracks and fractures as the piece cools after its first firing in a kiln. This is primarily due to the glaze having a higher shrink rate than the ceramic piece it coats. For earthenware this defect makes pottery unusable for holding fluids, but for true stoneware and vitreous bodies, water absorption is minimal and the glaze simply presents a hygienic, smooth surface. Crazing can be fixed usually through adjustments made to the glaze recipe.

Cristobalite – Silica. SiO_2. One of the primary phases of silica which are important to the potter. The other three are quartz, tridymite, and silica glass.

Deflocculation – The action of dispersing the fine clay particles in a slip so that the slip becomes more fluid. Slips that are used in casting are deflocculated and can thereby have a high density, which means that they can contain a high proportion of clay, while remaining fluid enough to be poured. Deflocculation is achieved by adding soluble alkalis to the water mix.

Dunting – Cracking of pottery caused by stresses which form during firing and cooling. The resulting crack is called a dunt. The main causes for dunting are the two silica inversions which take place at 1063°F (573°C) and 493°F (226°C). Differential contraction of body and glaze, without the action of a silica inversion, also causes stress which could result in dunting.

Earthenware – The simplest division of all pottery is into earthenware and stoneware. The main criteria for this difference is the porosity of the ceramics. If there is more than 5% porosity than the ware is considered earthenware. Types of earthenware include Raku, Slipware, Maiolica, Majolica, Creamware, Bone china, Soft-paste porcelain and Red Stoneware.

Epsom Salts – Small amounts of Epsom salts are added to clay recipes to increase plasticity. They are mixed with warm water and then introduced into the hydrated clay while is it mixed in order to ensure even dispersal. The ratio depends on the materials and their particle size and ultimate levels of plasticity. If too much is added, clay bodies will bloat and be prone to carbon trapping. It is best to add plastic clays for improved workability and rely on Epson salts for finer adjustments at the end.

Feldspar – A group of minerals used in proportions of up to 25% as flux in clay bodies and up to 100% in glazes. Feldspars contain alkalis plus silica and alumina oxide and are therefore natural frits or glazes. Their primary use is to introduce alkalis like sodium and potassium in reasonably insoluble forms. These two types are often referred to as Potash (potassium) and Soda (sodium) feldspars.

Feldspathoids – Not a true feldspar, but a family of minerals that does not conform to a single formula. Feldspathoids are alumina-silicates with various alkaline oxides. Two common examples are Nepheline Syenite and Cornwall Stone.

Fireclays – A type of clay associated with the Carboniferous Period over 280 million years ago. Fireclays are broken into two groups; compressed rock fireclays and underclays, which were the base for the coal forests of that time period and are always found immediately under a coal seam. Rock fireclays must be crushed and milled in order to be used while underclays are often found soft and damp, allowing for use after extraction. Characteristically, most fireclays are high in alumina but can contain other impurities such as free quartz, iron pyrite, and calcium carbonate. The presence of such materials means that clays made with fireclay must go through a slow bisque in order to burn out any organic matter and other impurities. Fire clays are traditionally used to add green strength to a clay body.

Flint – SiO_2. Cryptocrystalline native silica. Flint is characterized as almost pure silica, containing less than 5% calcium carbonate. Produced from chert nodules found in limestone, flint is usually calcined and then ground into a fine powder. Historically flint was the primary source for silica, but the modern way of acid-bathing pulverized granite slurries is now the common method of obtaining pure silica. Flint is added to clay bodies to provide a non-plastic and refractory addition, giving whiteness and anti-craze abilities. Flint, like other sources of silica is the primary cause of Silicosis, a lung disease.

Flux – An oxide which promotes ceramic fusion by interaction with other oxides. The oxides, which are usually referred to as fluxes, are the alkaline oxides because they interact with the glass-forming silica.

Glaze Fit – The relationship between ceramic and glaze where the two, bonded during a kiln firing, expand and contract in harmony with each other – or not, creating defects like crazing and shivering. It is impossible to get an exact fit, so there is some leeway and most glaze fit issues are fixed through glaze adjustments. Poor glaze fit can be adjusted through the clay body recipe, removing silica, sand, and grog in small amounts until defects subside.

Gault – A true marl of the Upper Cretaceous System of sedimentary rocks. It contains a high percentage – as much as 30% – of calcium carbonate in fine particles. The inclusion of calcium carbonate makes gault clays useful for earthenware temperatures and also as slip-glazes in firings above 2282°F (1250°C).

Greenware – Ware that has been completed in the making cycle, but has not dried sufficiently to be ready for firing. Usually at this stage one can apply slip-glazes for single firing.

Grog – Ground-fired body added to clays to provide a proportion of already fired and often refractory material. Grog provides texture, both tactile and visual, along with better bite for control in throwing and forming. It is often called an "opener" because it is already fired and helps the clay dry more uniformly, especially with larger work.

Inversion (Quartz) – A phenomenon by which quartz undergoes a reversable change in its crystalline structure starting at 1058°F (570°C) from alpha-quartz to beta-quartz. If this change occurs too quickly it can lead to cracking in ceramic wares. This is why it is important to slowly heat ceramics at the beginning of a firing and subsequently cool the work at a slow rate, avoiding any exposure to rapid cooling during certain periods (122°F [50°C] per hour). Dunting will occur if ceramic wares are cooled too fast, especially if there are high levels of free silica already present.

Kaolin – China clay, the purest clay and the closest version of the idealized clay mineral kaolinite. It contains very few iron impurities and is therefore white in color. A coarser clay than ball or fireclay, due to being a primary clay, and usually found not far from the parent material, usually weathered granite.

Marl – Specifically a natural clay containing iron oxide and a high proportion of calcium compounds. Marls are used as potting clays for low-fire earthenware and brick clays.

Maturation Point/Temperature – A temperature range at which any clay body arrives at its peak vitrification, achieving ideal strength and density. Below this range and the clay is underfired, above and the clay body over-vitrifies and can bloat and warp – eventually melting. For earthenware clays, full of fluxes, this ideal range is between 1742–1922°F (950–1050°C) which is much lower than that of fireclays and kaolin, between 2192–2552°F (1150–1400°C). While some individual clays have extended maturation ranges, like fireclays (360°F [182°C]), clay bodies may have shorter ranges (50–100°F [10–20°C]) due to the presence of fluxes like feldspars, talc, and iron oxide.

Molochite – Grog. A trade name for calcined china clay and used a refractory, white grog in porcelaneous clays. It is composed of mullite and amorphous silica glass with no crystalline silica, providing low and uniform thermal expansion.

Mullite – $3Al_2O_3 \cdot 2SiO_2$. Alumino-silicate crystals with long needles that interlace along with molten silica to create a strong body as a product of vitrification. During peak temperatures, kaolinite crystals flux out and

decompose as the free silica present in the clay body melts and fluxes the silica in the clay molecules, leaving a new alumino-silicate structure high in aluminum. Mullite becomes present above 1832°F (1000°C) but one must fire above 2012°F (1150°C) to ensure proper crystal growth. This is why stoneware and porcelain clay bodies are stronger than earthenware clays that are simply a fusion of meta-kaolinite crystals with oxides and other fluxes. A good way to add mullite to clay bodies is through an addition of molochite.

Oxidation – A kiln atmosphere intended to achieve oxidation is called an oxidizing atmosphere. It occurs at temperatures above red heat and is achieved through the introduction of excess air to the fire, or allowing air to track through the muffle on a gas burner.

Plasticity – The unique property found in clays that combines the strength of a solid material with the fluidity of a liquid. With the absence of elasticity, plastic clay can be shaped and reformed without rupturing and will maintain its intended shape. Plasticity is both an individual quality and an overall ideal, where clays of different particle sizes are blended to create plastic clay bodies capable of being easily shaped but also strong and keeping their form. Plasticity can be broken down into six factors: particle size, actual clay content, water/moisture content, particle alignment, plasticizers, and particle bond strength. Each factor changes with different clays and often individual clays with different strengths (factors) are combined to create clay bodies that exhibit a balance of strength and plasticity.

Porcelain – A vitrified, white transparent ware, usually fired in temperatures above 2372°F (1300°C). The essential ingredient for the body of these high-fired porcelains is a plastic white-burning clay, kaolin.

Porosity – A term used to describe water absorption in clay bodies with different vitrification rates. Ceramic that is properly vitrified, like stoneware, absorbs little water (2–4%) while earthenware clays like terracotta are extremely porous and hold no water whatsoever. Porosity in ceramic wares can be adjusted through firing times, fluxes, and silica ratios. See **Water Absorption**.

Pyrophyllite – A low-expansion mineral often used in clay bodies like porcelains and stoneware to encourage the development of mullite, increasing the overall firing strength while reducing thermal expansion. This helps with warping and cracking at peak temperatures, hence the use of pyrophyllite in wood-fire clay bodies. Small amounts can be substituted for silica, though one needs to be aware of changes to glaze fit due to lower levels of silica present in the clay body.

Reduction – The action of taking oxygen away from metal oxides. For ceramicists, reduction is used to create different effects from the same metals used in clays and glazes. Iron, specifically, changes the color and vitrification rates in stoneware clay bodies when exposed to a reduction atmosphere.

Refractory – Resistance to high temperatures, which varies depending on the circumstances. For industry, refractory materials have a peak temperature of 3092°F (1700°C) while for the potter, the term refractory is often used with temperatures around 2372°F (1300°C) and in reference to clay bodies and other materials that can withstand those temperatures without deforming.

Shivering – A glaze defect where a glaze starts to shear away from the body of a pot in small shivers, usually around outside sharp edges like rims, handles, and throwing marks. While considered a glaze defect, it is actually a fit issue between the clay body and the glaze, and is usually solved by adjusting the silica to flux ratio or the clay content of the glaze recipe.

Shrinkage – Refers to a decrease in overall size of a raw clay due to drying and firing. While drying shrinkage can be reversed by rehydration through adding water, firing shrinkage is permanent due to the loss of chemical water in the clay particles, changing the chemical nature of the clay and creating ceramic. There are two stages of shrinkage in pottery: from clay to bisque and then in the final firing from bisque to its true ceramic stage. Different clays have different shrink rates depending on how plastic the clay is and how much water the individual clay particles absorb. For raw clays and clay bodies it is also dependent on how many non-clay materials are present, like sand and grog. Shrinkage can be measured by making test bars out of sample clays.

Silica – SiO_2. Quartz. Flint. One of the most important materials to any ceramicist, silica is essentially the backbone of most clay bodies and a primary constituent of glazes. Silica is a glass-former and works in tandem with mullite to create the vitreous qualities found in any ceramic material.

Slaking – Slaking is the process whereby materials, like clay and crushed rock, disintegrate in water. In most cases slaking is the easiest way to render a clay down to slip, but only if the clay is completely dry and fully immersed in water. Clays with finer particle sizes or those that are derived from mud and siltstones are often difficult to break up by slaking and often require additional mechanical processing, such as milling and crushing.

Slip – Any clay or clay-like material suspended in enough water to be fluid. Slips can range from simple watered-down clay scraps to calculated recipes involving fluxes and single-sourced dry clays.

Stoneware – High-fire ceramics made from refractory iron-rich kaolin, fire and/or ball clays. Peak maturation is around 2372°F (1300°C) and most traditional stoneware clays are considered plastic and naturally workable with few additives needed for plasticity.

Talc – Magnesium silicate with the ideal formula of $3MgO \cdot 4SiO_2 \cdot H_2O$. Used as a flux in mid-range and earthenware clay bodies, Talc can also be used in stoneware clay bodies to help with thermal shock. Too much talc present leads to bloating in mid-range and stoneware clay bodies due to its melting temperature – decomposing at 1652°F (900°C). Talc has also been shown to reduce crazing in glazes when added directly to earthenware clays.

Thermal Expansion – The degree to which ceramic materials expand (and contract) when exposed to increased temperatures. While there are some exceptions (flame ware has almost no measurable thermal expansion), most ceramic bodies exhibit some level of thermal expansion which can impact glazes, causing crazing and shivering if a proper glaze fit is not accounted for. Thermal expansion rates are directly related to vitrification, and clay bodies that include mullite and pyrophyllite have lower expansion rates and are ideal for direct flame contact like those found in wood-fired kilns. Clays with high levels of free silica are often over-vitrified and react poorly to thermal expansion, creating dunting and cracking issues as the ceramic cools.

Thixotropy – The quality by which clay slips become more viscous when left to settle, but return to a fluid state when stirred. It is also used to describe the ability of wet clays to maintain their given shape as shown in casting slips. A desired level of thixotropy is often induced using materials like Epson salts or chemicals like Darvan.

Vitrification – the peak stage in a firing for a clay body before it starts to melt and deform. At this point in the firing the ceramic form is in a malleable state, being easily deformed by applied pressure. Any further increase in, or exposure to, the current prolonged temperature will result in bloating and deformation as the ceramic becomes fluxed and fluid, buckling under its own weight. This is the direct result of fluxed feldspathoids and free silica in the clay body, and once cooled the clay particles are welded together by the glassy matrix, creating a durable ceramic. In clay bodies with over-vitrification, too much glassy matrix has formed and the resulting ceramic is brittle. Therefore, some porosity is desired as it makes for a stronger, more durable ceramic object.

Water absorption – In some cases, clay can contain up to 40% of its weight in water, 20% being used as a lubricant via plasticity, 10% embedded in the pores in and between the clay particles, and 10% being chemically bonded within said clay particles. The more water that can be absorbed by individual clays, the higher the shrink rates become. This can be the trade-off as clays that have higher rates of plastic (lubricant) water are easier to work with since these water molecules allow the clay particles to slide across one another. Some clays, like bentonite, absorb large amounts of water and swell in size, making them difficult to use in large amounts.

Wollastonite – Calcium silicate. $CaO \cdot SiO_2$. A valuable material for earthenware and tile-ware, wollastonite can reduce shrinkage and warping as well as promoting lower thermal expansion. In some low-fire clay bodies as much as 10% can be added to aid in fluxing and vitrification while smaller increments (2–5%) have been used to substitute out talc in mid-range clay bodies to help with shrinkage. Wollastonite has also been tested in high-fire clay bodies where alumina levels are higher and the SiO_2 and CaO found within can easily form silicates ideal for high temperature sanitary ware. Some artists have also demonstrated strong color responses in clay bodies used in high-fire atmospheric kilns.

Workability – The quality of a clay which describes the combined characters of plasticity, strength, and thixotropy. These qualities overlap in some areas and are hard to isolate in terms of identifying direct benefit to the ease of use. In order to achieve an effective level of workability, one must know which of the three qualities are best suited for the task at hand. The workability of a slip-casting clay varies largely against the workability of a throwable stoneware clay. The lack of workability is often referred to as being short. A test for workability in raw clays found in the landscape often involves a coil test where the clay is wetted, formed into a coil and tied in a knot in order to test the above qualities. If the clay can be tied into a knot without cracking or breaking it is shown to be plastic, while still being able to hold its coiled shape demonstrates the qualities of strength and thixotropy. Often these qualities are balanced by blending clays together, utilizing the best of their specific qualities, such as plasticity and green strength. It is rare that a singular clay demonstrates all three qualities with minimal additions and processing.

WILD CLAY TEST DATA SHEET

Date:

Clay sample name:

Location:

Description:

Note:

Test tile	1	2	3	4	5
Wet weight (before firing)					
Dry weight (before firing)					
Dry length (before firing)					
Firing temperature (Cone No.)					
Firing color (after firing)					
Firing length (after firing)					
Dry weight (after firing)					
Soak wet weight (after firing)					

Water in the clay (%)					
Dry shrinkage (%)					
Firing shrinkage (%)					
Water absorption (%)					

Average water in the clay (%)	
Average dry shrinkage (%)	
Average firing shrinkage (%)	
Average water absorption (%)	

Sieve analysis # 16 # 30 # 50 # 100 # 200

 # 300 # 400 Under # 400

Note:

CLAY BODY TEST DATA SHEET

Date:

Sample name:

Process:

Raw color:

Plasticity, workability:

Note:

Recipe	Materials	%	g

Test tile	1	2	3	4	5
Wet weight (before firing)					
Dry weight (before firing)					
Dry length (before firing)					
Firing temperature (Cone No.)					
Firing color (after firing)					
Firing length (after firing)					
Dry weight (after firing)					
Soak wet weight (after firing)					

	1	2	3	4	5
Water in the clay (%)					
Dry shrinkage (%)					
Firing shrinkage (%)					
Water absorption (%)					

Average water in the clay (%)	
Average dry shrinkage (%)	
Average firing shrinkage (%)	
Average water absorption (%)	

Note:

INDEX

References to images are in *italics*.